KB161683

FASHION BIZ
IN
DONGDAEMUN
MARKET
SEOUL

To my lovely grandsons Jay Kim and Lucas Sul

FASHION BIZ

IN

DONGDAEMUN
MARKET
SEOUL

Bong(Bong Sik) Sul

이담북스

"Have you been Seoul, Korea?" There, in Dongdaemun market, a popular destination, many wholesalers are achieving great management performance with their unique fashion business strategies and marketing. This will be of interest to fashion retailers and buyers from all over the world, as well as influencers with a big business dream.

In one word, this book is a friendly message sent as express mail to them all. A fashion legend Yves Saint Laurent said.

"Fashion fades, style is eternal."[1]

Contrary to his argument, however, consumer's preference for fashion products lasts for a while because fashion has a longer life-cycle than fad.

Of course, style is a keyword used to mean that some fashion products are widely preferred in the long term as more standardized goods and services, as he argued.

As such, the marketing of fashion products is closely related to the products' life-cycle and market response.

In terminology, fashion marketing is a business activity based on meaning like the compound word of 'market' and 'ing' for fashion products.

Be the matter what it may, marketing is different from 'selling', one of the business activities in the market. In particularly, it is not only to sell products that are already manufactured in the market.

In other words, it is correct to say that fashion marketing is not just selling, but producing. That's why fashion business companies are often interested in surveying and analyzing consumer needs and wants. Philip Kotler also had the same view.

"Marketing is becoming a battle based more on information than on sales power."[2]

Lots of fashion companies that produce and supply

luxury fashion products, SPA brands, or other fashion products have marketing strategies as 'manufacturers,' but Dongdaemun fashion marketing is led by 'wholesalers.'

Over 30,000 wholesalers in the world-class Dongdaemun Fashion Cluster are performing marketing strategies by supplying new and diverse fashion products through a business system of the supply-side management. Each wholesaler in Dongdaemun market has three to four designers, including freelancers, and marketing performance of the market is improving thanks to the creative and diligent efforts of all Dongdaemun designers, which number more than 100,000.

In addition, Dongdaemun-style of fashion biz has a new merchandising strategy every three days for fashion products that are custom-made in partnership with numerous sewing factories in Gangbuk, Seoul.

It should be noted that even if Dongdaemun wholesalers are working 'in the market,' they continue their marketing strategy in cooperation with the supply-side sewing factories.

We can say, therefore, that Dongdaemun-style of fashion business & marketing is not a selling, but a production activity. The starting point of those marketing strategy depends on what and how it is produced.

As we all know, the market is, on the one hand, a place where producers and consumers meet each other and exchange commodities, and on the other hand, it is also a space of life where many people exchange valuable market information about products and price, and so on.

Based on the valuable market information obtained from 'the market,' Dongdaemun wholesalers often decide what fashion products, when, and how much they manufacture and sell. That's Dongdaemun-style of fashion biz.

Nowadays, many consumers at home and abroad no longer prefer fashion products that are mass-produced with automated machines. Rather, they prefer their own fashion style's products for personalization.

In fact, many fashion companies today may sometimes be selling products that are different from the wants and needs of consumers.

It is true that most of the products of global SPA brands are not merchandising products of 'newness and variety'. Of course, luxury fashion products are producing customized fashion products according to changing trends, but it is true that the products also lack variety.

Maybe they all have forgotten the proverb "There is

no accounting for tastes."

On the contrary, Dongdaemun fashion products sell well because the items shipped fit with consumers' bodies and can quickly adapt to changing trends due to the characteristics of products with novelty and variety.

Many domestic and foreign fashion retailers and buyers can easily select and purchase a variety of items that suit consumer needs and wants at Dongdaemun market.

Wholesalers in Dongdaemun market are achieving sustainable management performance with unique fashion marketing strategies. We are sure that Dongdaemun-style of fashion biz will continue its market competitive edge.

"There are plenty more fish in the sea."[3]

It means that everyone has a good opportunity, not once or twice, but quite a lot. Thanks to this great gift from God, we may always be rewarded in the work given to us.

After retiring as a professor at one university in February 2010, I went to Dongdaemun market, a fashion shopping mall, and published three books written while doing empirical research based on what I saw and felt there.

The books are Dongdaemun market, where dreams are (Korean version, 2016), Dongdaemun Style (English ver-

sion, 2019), and Fashion Marketing, Dongdaemun-style and its strategy (Korean version, 2022).

Among them, the previous two books only analyzed and synthesized the behavioral characteristics of Dongdaemun wholesalers and the market phenomenon. And the third and fourth books were upgraded to normative research based on the empirical research on the Dongdaemun market.

The fact being given, the theory being makes sense. That's definitely right. Isn't it said that science systematically explains phenomena? In this belief, I thought that I would like to share and communicate the contents of this book with many readers around the world.

I titled this book 'Fashion Biz in Dongdaemun Market, Seoul', and further improved the contents of my previous writings by revising them.

In this book, I tried it to explain the strategic alternative to Dongdaemun market's fashion business as entrepreneurship.

According to Schumpeter's theory on entrepreneurship, management performance of a company depends more on the merchant's mindset as an entrepreneur than on the size of capital and the other physical resources, etc.[4]

Undoubtedly, the people of Dongdaemun market are

not only wholesalers, designers, and employees of a sewing factory, but also true merchants with diligent and outstanding entrepreneurship. They are all quite innovative entrepreneurs. Trust me, please.

I hope that many readers will recognize that there is quite a wonderful marketplace and open their hearts to this book.

Thank all of you, indeed.

<Notes>

1 The Lives of 50 Fashion Legends, Fashionary, 2018, p.47.

2 Professor Philip Kotler is a well-known scholar in the American marketing academia, and his book is famous.

3 Prime English-Korean Dictionary, 6th Ed., www.bookdonga.com., 1951, 2021.

4 Joseph Schumpeter, Economic Development, Harvard University Press, 1936.

Contents

Part
1

Fashion, Life Value, and Happiness

Fashion and Value of Life

"I don't design clothes. I design dreams."[1]

Fashion products are the fruit of dreams made by any designer. And it further raises the products value.

The value of a commodity is the sum of the economic value and emotional value of the products. In particular, in the case of fashion products, there is a tendency to consider the increase of emotional value more important than economic value.

"The fashion industry is not a price, but everything else is fashionable again."[2]

Any item can easily become fashionable once it reaches the hands of a certain designer, and sometimes even outdated items can become fashionable again. As soon as an item becomes popular, however, the trend changes and sometimes goes out of fashion.

As such, designer products sell well thanks to the in-

crease in the emotional value of the item. On the other hand, if an item of the products does not sell well, it has no meaning as a valuable designer item. In fact, the needs and wants of all customers are always changing, so designers will have to adapt well to these changes in the market.

"I do not trust fashion, but I rather believe in the customer. I think that life is so short that it is difficult to meet the same customers every day."[3]

The reason for this is that consumers often confuse the value of the logo with the emotional value of any fashion products. But true fashion products are never a logo. Rather, fashion products enhance customer preference with the emotional value of images such as silhouette.

We are understood that there are seven emotional expressions universal to people all over the world. They are happiness, sadness, surprise, fear, anger, disgust, and contempt. Manufacturing and sales of fashion products, therefore, should improve the value of the products in the direction of enhancing positive factors instead of negative factors among such emotional expressions.

"Positive emotions about consumption are known to improve consumer satisfaction, whereas negative emotions

decrease it. The results show that both positive and negative emotions significantly affect not only consumer judgment but also satisfaction."[4]

While this discussion is understandable by all, it may need further emphasis. And while functional, monetary, social, and psychological values are all important, it is necessary to focus on psychological values among them.

As a result, designers working in Dongdaemun market tend to create demand for their customers by trying to increase the emotional value of their products. What they design and produce is called the designer brand, and it is a strategy to enhance the emotional value of the products.

They are like the Midas touch, a legend that everything touching by the hands turns into gold. That's right.

In addition, many Dongdaemun merchants and sewing factory employees are also satisfying the needs and wants of consumer by valuing the designers' works into better products and selling them at lower prices.

On the other hand, the consumer's view of fashion products in Dongdaemun market is still that the quality is not good even though it has a trendy and creative design.

All products do not have a long life-cycle unless their economic value, which depends on their quality, is further improved. Likewise, any fashion products should continue strategy to improve its emotional value while improving its economic value. As discussed by Janelle Barlow and her co-author, the emotional value of a commodity is 'economic worth of feeling'.

"These feelings create a desire in consumers to want, to return to a place of business or go away and never come back."[5]

It is certain that emotional value of a commodity as much as its quality can make money or not. One strategic alternative to increase the emotional value of the products would be some solution from the following discussion.

"The issues to be discussed are (1) value what they value, (2) avoid one-size-fit-all, (3) put yourself in their shoes, (4) rely on real insight, but not best guesses, (5) create winwin scenarios."[6]

Mrs. Barlow's argument that she interprets emotional value as the economic value of feeling is correct.

"Emotional value, as much as quality or any other dimension of an organization's worth, can make or break a business."[7]

Clothes make the Man

"Fine feathers make fine birds."

Widely understanding, this proverb has the same meaning as "Fine clothes make a man." 'The Fairy and the Woodcutter,' one of the most popular of all Korean folktales, is telling a story about the wing clothes and the beautiful love of the two protagonists.[8]

There once was a poor woodcutter who lived with his mother. One day, he helped a wounded deer escape from hunters.

In taken of gratitude, the deer informed the woodcutter of a nearby pond where fairies came down from heaven to bathe every month. According to advice of the deer, the woodcutter hid the fairy's winged clothing and was able to marry one of the fairies who never returned to heaven.

In this beautiful love story, the poor woodcutter lived

happily with the fairy until he had two children. However, he forgot the deer's advice to never return the fairy wings, which he had hidden before giving birth to three children, and gave them back to the fairy. Then the fairy returned to heaven.

In this way, the legend eventually became a story about sad love. As such a folktale, the clothes are worth more than anything. It is also not wrong to say that clothes are like wings.

Needless to say, the basic needs of human are clothes, food, and housing and so on. When Koreans say this term, they prioritize clothes over food. An American famous writer, Mark Twain said.

"Clothes make the man. Naked people have little or no influence on society."[9]

With regard to his words, which he put forth almost 100 years ago, people later interpreted the meaning differently. Someone said that in Shakespeare's work 'Hamlet,' it comes from the dialogue "Apparel oft proclaims the man." Contrary to this claim, others have seen it mean people are judged according to way they are dressed.

On the other hand, it is clear that the clothes we wear affect our behavior, attitudes, personality, mood,

confidence. The quote that clothes make the man, therefore, also means that dressing well helps people to be successful.

We are now discussing for clothes, one of the basic needs, and its fashion biz & marketing strategies. The problem is that many people believe that an item of products sells well when it is widely advertised.

Fashion biz & marketing, however, is more about manufacturing and selling better fashion products as a style that fits rapidly changing trends and spreads widely rather than just fad products. That much better clothes make the man is truly a good fashion item.

Above all, fashion biz & marketing should be a strategic means of producing and selling better products that enable consumers to stand out in their actions, attitudes, moods, personality and confidence.

Domestic and foreign buyers who have visited Dongdaemun market at least once are well aware that they can purchase new products such as this and that at any mall in the marketplace.

Rather, based on their consumer satisfaction, many buyers enjoy purchasing Dongdaemun fashion products. They will be well aware of the fact that consumers are shopping by thinking that "Clothes are like wings."

Dongdaemun merchants must carefully make the products their buyers want and sell them at lower prices. Only then will their buyers visit Dongdaemun market again.

As such, in our discussion of 'clothes make the man', it is not different from the significance of sustainable marketing in fashion, which has recently become a hot issue.

As we all need to share, the true meaning of sustainable marketing in fashion is a type of marketing that promotes the environment and socially responsible products, as well as brand values.[10]

Needless to say, these commerce code of conduct to be pursued in the Dongdaemun market is a sustainable technique of fashion marketing and furthermore, the value of business life of everyone in the market.

Fashion and Happiness

A figure like a giant tree in the fashion business world, Yves Saint Laurent said that good clothing is a passport to happiness. Another fashion legend, Hubert de Givenchy said it is most beautiful in the world to give happiness to people.[11]

What does happiness mean? According to an allegory, an English gentleman walking in the garden told the bird crying.

"I don't cry because I am happy."[12]

Then the bird immediately responded, saying, "I am happy because I sing." We don't know whether birds sing or cry. It is rather true that people have different ideas about whether the birds cry or sing. Whichever is right, we want the birds to never cry and always sing.

As widely accepted, happiness is influenced by seven factors like family and love, money, work, friends and

social relationships, health, freedom, and self-esteem. At least four or five of these factors of happiness are related to 'human relations.' Even other factors that were excluded here are not irrelevant to human relations.

From this discussion, there are all kinds of clothes, but especially fashion clothes will bring happiness as long as people are social animals with frequent relationships. Certainly, the fashion legends revealed earlier generally said that high consumer satisfaction of fashion products is the goal of all fashion businesses.

Of course, there are quite a few people who say that the rich are not always happy. On the contrary, an American film and TV actress, Bo Derek said eloquently.

"Whoever said that money can't buy happiness simply didn't know where to go shopping."[13]

A legendary actress, Marilyn Monroe also said already that happiness is not in money, but in shopping.[14] When a household's income increases, its expenditures that satisfy basic needs of human such as food, clothing, and shelter increase, and accordingly, their happiness becomes more. Under these economic laws, shopping increases consumer satisfaction just as much as needs and wants.

Given these general economic phenomena, a clear state-

ment by an American actress is widely acceptable.

As the well-known economic phenomenon of Engel's Law explains, as household income increases, the ratio of food expenditure to income decreases. This economic law, therefore, means that as household income increases, the proportion of non-food expenditures such as clothing and shelters to income increases.

In this situation, one economist said that as the cost of manufacturing products with automation and technological innovation fell and living cost of products in the labor-intensive service industry increased, any households' consumption behavior changed. We called this phenomenon 'Baumol's disease' in the name of the economist.[15] This syndrome is caused by a fall in the price of manufactured goods and an increase in the price of service products.

On the other hand, luxury fashion products often increase the burden of household expenses for the products, although the products are manufactured labor intensively. This is even more so because consumers who prioritize emotional value prefer the latest products amid rapid trend changes.

As such, it is natural that consumption expenditure on fashion products of many households increases rap-

idly with economic growth. For the general public, however, there will probably be a side effect like feeling of relative poverty.

For these and other reasons, the growth of global SPA brand companies is following, and consumer preference for fast fashion products is increasing. In fact, global SPA brand companies are making a lot of money by supplying fast fashion at low prices, but they are unable to achieve sustainable management due to delayed shipment of trend-oriented new products and lack of diversity in merchandising.

As a marketing alternative, Dongdaemun merchants with comparative advantages in products, speed, and price are conducting sustainable management through partnership with designers like a craftsman and entrepreneurial executives and employees of small but strong sewing factories.

Before and after the Covid-19 pandemic, lots of sewing factories around the world were closed, but sewing factories around Dongdaemun market are still operating 24 hours a day. And, thanks to the performance of their suppliers' business, the Dongdaemun wholesale market is also busy from 8:30 pm until the sun rises the next morning.

CEO Lee Yong-woo who currently exports Dongdaemun fashion products, fabric and parts as an agent for purchase, said that we take great pride in selling good products at low prices to make global consumers happy.

With quality management as the top priority, the company has an inspection system, and exports through five steps such as size measurement, detailed inspection, labelling, ironing, wrapping in plastic bags and putting bar-code, packing in box and shipping. CEO Lee is shouting.

"Click on our website. We will give a gift bag with happiness to global fashion retailers and buyers."[16]

In addition, people in Dongdaemun market are said to be adjusting their marketing strategies to suit the needs and wants of global consumer for a happy business life.

Fashion and Consumer Needs

When we discuss about fashion, life, and happiness, the consumer is at the center of the debate. This is contrary to calling them final consumer, based on the fact that any fashion products flow from producer to consumer.

Considering that any fashion item is produced according to demand based on the needs of consumers, however, it can be said that producer behavior also begins with consumer behavior.

They, fashion consumers, satisfy their basic needs by buying clothing or fashion accessories for personal use or as a gift for others. Fashion marketers, therefore, need to know what and how much they are buying. Scott Cook, a director of eBay, is giving us almost the same advice.

"Instead of focusing on the competition, focus on the

consumer."[17]

This fashion biz & marketing strategy that focuses on consumers rather than competitors will be the touchstone for achieving management performance. In relation to this debate, consider the eco-system of flower and its behavior.

Most flowers have symbiotic relationships with customers such as bees, butterflies, flies and beetles to reproduce, grow and survive. Although there are differences between flowers, most of them try to satisfy those customers by producing honey and fragrance.

Flowers that bees visit have inherently nectar and scent. In particular, the petals and sepals are often blue, yellow, or a mixture thereof. This is believed to be because bees can only discern yellow, blue, and white. And, butterflies generally prefer orange or red flowers.

Other creatures that sit on the flower seek the various flowers in the same or different ways as bees and butterflies. Among them, flies like almost the same kind of flowers as bees, but houseflies do not identify by color and like flowers because of their smell. Beetles only seek flowers for their scent, and mosquitoes are active only at night, so they prefer white flowers that are easy to see at that time.

Even more surprising is that some flowers have unique survival and reproduction strategies that invite flies to smell like insect corpses.

From this point of view, it can be said that the survival strategy of flower is to produce honey and fragrance customized for consumer. Similarly, fashion biz & marketing needs to use various customized strategic alternatives according to consumer.

"Marketing is the process of planning and executing the conception, pricing, promotion and distribution of ideas, goods and services that satisfy individual and organizational goals."[18]

As such, the American Marketing Association's theory on marketing and its prescription will be like a medicine that brings better management performance to Dongdaemun merchants.

For nearly 100 years, Dongdaemun merchants have accumulated a lot of experience and know-how by meeting, seeing, and listening to consumers in the market, and also looking for various strategic alternatives.

Even with all these facts, there are many things that we need to reconsider and check again. Among them, it is the task of preparing a new marketing strategy for the global market.

Such global marketing is inevitable because global consumers no longer shop only in their own country, but purchase multinational fashion products online or offline across borders. The issue of any paper is worth listening to.

"It is noteworthy that a new kind of society is emerging, which is now centered around consumers and consumption rather than workers and production. And, despite the growing commonality among people around the world, the consumer behavior varies according to the environment and culture of the country. Marketers need to understand the values, ethics and customs of societies around the world to succeed in the global marketplace."[19]

Such discussion implies that Dongdaemun merchants can no longer rely solely on their experience and know-how. There are strategic alternatives to global marketing. When Dongdaemun merchants focus on the global consumer, they will certainly respond.

These are, first, to improve the quality of fashion products, second, to have stronger market competitiveness, third, to raise global consumers' awareness of Dongdaemun fashion products, and finally, to reduce the cost of global marketing. These strategic alternatives

to global marketing, which Dongdaemun merchants should do, will have to be pursued continuously. Henry Ford's eloquence is right.

"The one who can give the consumer the best quality at lower prices, will certainly be at the head of the industry, no matter what goods he produces. This is an immutable law."[20]

Just as many flowers survive with their customer, such as bees and butterflies, Dongdaemun merchants should also implement a sustainable fashion biz & marketing strategy that focuses on the consumer rather than looking at competitor.

Products, Speed, and Price

"In any products, when the quality is good, the trend is fast and the price is low, the consumer's preference for the item increases."[21]

As widely accepted, it is one of the iron principles of economic theory on scarcity and choice. In fact, many fashion companies aim for marketing and PR strategies to manufacture good products faster and sell them at lower prices as possible, but it is difficult to have these three strategic tools together.

This is because there are the following limitations in applying these triple strategic tools together.[22]

(1) To manufacture and sell something fast and high quality, the cost increases that much.

(2) To manufacture and sell something faster and cheaply, its quality is difficult to improve.

(3) To manufacture and sell something of high quality

at low cost, it cannot be that fast.

Dongdaemun market, however, overcame the limit through triple management by balancing the importance of products, speed and price. Will this work well in the market? Anyone can doubt whether Dongdaemun merchants have such magical commerce and its techniques. So, people often say this.

"Merchants lie very often like having lunch or dinner every day."[23]

It is also written as "A commercial is a kind of lie, so you should take it as such." in the English dictionary. Anyway, it is human nature to lie, and man must be one of those selfish creatures. No one can deny this claim.

In that market, however, they are doing well in the commerce of triple management, which is difficult to achieve. There is a unique marketplace that produce good commodities faster and sell them at lower prices. There is only one market in the world. Someone may not believe it, but it is true.

In particularly, Dongdaemun wholesale shopping center is crowded with many domestic and foreign buyers thanks to triple management of products, speed and price. This triple management is still in the spotlight.

For anyone, it would be difficult to understand how the people in the Dongdaemun market were continuing such a marketing strategy. Fortunately, I found the answer in that marketplace. Watching the market there for years, nothing, unless an echo, I was heard. Or rather, the market voice was in the echo.

As we all know, Dongdaemun market started to manufacture and sell various fashion products from the early 1960s, when it was the first decade of development. More notably, it was very unique business style that was 'produced in one place and sold there.'

At a time when Korean economy was in the developing phase, many small sewing factories and stores for subsistence were forced to produce and sell better fashion products at lower cost of production.

In particular, the reason why they were able to sell more at such a low price at that time was because, more than anything else, the system of perfect competition was maintained amid oversupply.

As the phenomenon of Adam Smith's laissez-faire market, Dongdaemun market actually manufactured good fashion products quickly and sold them cheaply by the action of the invisible hand. In the market, where many suppliers meet many consumers, the competition has im-

proved the quality of the products traded, lowered the price level, and accelerated the manufacturing speed of those products.

Laissez-faire economy discussed by the father of economics Adam Smith and its virtue explains why Dongdaemun merchants' competitiveness in the global fashion market has been improved.

Furthermore, the continuation of such fashion management and its marketing strategy is due to the establishment and development of the so-called Dongdaemun Fashion Cluster.

The outdoor advertisement of storytelling at Pyeonghwa market, which has a history of nearly 80 years in the Dongdaemun Shopping District, is written as 'a miracle site where design, production, distribution and consumption take place in just 3 days.'[24]

When we say that the meaning of a miracle is "a task that is difficult for humans to achieve," this three-day miracle at Dongdaemun market is one of the valuable rewards of accumulating experience through diligent work under 'a quickly and quickly spirit' that is unique to Koreans. This is also something that is praised by people around the world.

Although global SPA brand companies and their mar-

kets were growing rapidly in recent years, the fast fashion industry in Dongdaemun market has already started in the early 1960s for the first time in the world, and its boom has continued.

Unfortunately, most global SPA brand companies are in a state of instability as well as growth retardation amidst the global society's condemnation about the products' quality deterioration, failure to adapt to trends, and deterioration of the working life of factory workers, and so on.

On the other hand, Dongdaemun market is adapting well to trends and increasing the satisfaction of domestic and foreign buyers by manufacturing high-quality fashion products and securing their diversity, as well as reducing cost of production and maintaining low prices.

As such, the people of Dongdaemun market are not stopping the sustainable fashion business management of manufacturing good fashion products according to the trend at a faster speed and selling them at a lower price.

Despite various sacrifices of the people in the market such as unsatisfactory design work allowances, unsatisfactory wages, poor working conditions, and not much distribution margins, they lead a happy business life with

domestic and foreign fashion retailers, buyers, and global consumers.

Many economists may already be praising this phenomenon in terms of 'opportunity cost'. Instead, it can be explained as the entrepreneurship of Dongdaemun merchants or their mindset.

Dongdaemun market, which has a unique fashion marketing strategy that cannot be found anywhere else in the world, is still crowded with many people both inside and outside their shops' show windows. And they are still busy.

<Notes>

1 The 50 greats fashion quotes of all time, www.harpersbazaar.com

2 www.google.com

3 www.google.com

4 www.google.com

5 Janelle Barlow and Dianna Maul, Emotional Value-Creating Strong Bonds with Your Customers, www.bkconnection, 2000.

6 Ibid.

7 Ibid.

8 korea.net/News Focus/Culture. "The Fairy and the Woodcutter: tragic love, Korean style."

9 www.goodreads.com/book/Wisdom-of-Mark-Twain

10 www.brainyquuote.com/topics/clothes-quotes

11 www.google.com

12 Richard Layard, Happiness: Lesson from a New Science, Penguin Book, 2005, p.188.

13 www.google.com

14 www.google.com

15 Andreas Chai, "Household consumption patterns and the sectoral composition of growing economies," Griffith Business School, December, 2018.

16 www.seoulclick.com

17 www.brainyquote.com/authors/top-10-scot-cook-quotes

18 www.ama.org/the-definition-of-marketing-what-is-marketing/

19 Martin Luenendonk, Global Marketing: Strategies, Definitions, Issues, Examples, Clever, September 23, 2019.

20 google.com/search/q?

21 Bong (Bong-sik) Sul, Dongdaemun Style, ebook.kstudy.com, 2019, pp.16-17.

22 Ibid.

23 This is a proverb used by Koreans.

24 Bong (Bong-sik) Sul, Fashion Marketing-Dongdaemun-style (Korean version), ebook. kstudy.com, 2022, p.20. www.peonghwamarket.com

Part
2

Fashion and Entrepreneurship

Fashion and Entrepreneurship

Coco Chanel was a legendary fashion designer. In fact, however, the debate about whether she was a designer or a fashion entrepreneur differs from person to person.

As it is widely known, fashion designers are different for each company, but there are many entrepreneurial designers. From another point of view, a fashion designer as an entrepreneur has the following two tasks.

First, it achieves the performance through diligent and creative design work. Second, it is to devise and operate better commerce management and its strategic alternatives for the fashion products.

In this way, the designer as an entrepreneur must take a broad view of all the work of the company. They have to deal with the changing circumstances inside and outside the company and choose what to do

and what not to do each time.

Because the fashion business is people-oriented, designers must communicate with many people and maintain friendly relationships. They have a lot of people to meet, such as stylists, MDs (buyers), pattern makers, seamstresses, fashion designers, modeling office workers, design companies and their magazine editors.

In the history of the fashion business world, there was many entrepreneurial designers like this, and it seems that their great business life was also dynamic.

The first person that comes to mind among these entrepreneurial designers is Coco Chanel, the godmother of modern fashion. She is known worldwide as one of Time magazine's '100 Most Influential People of the 20th Century.'[1]

The precious legacy she left behind is the Chanel brand itself, which has been a powerful force in the history of the global fashion market for the past 100 years and then some. Undoubtedly, she is the unrivaled hero of the first fashion revolution in human history.

Coco Chanel was born in Paris, France in 1883. After that, when she was 12 years old, she lost her mother and losing her father too she entered an orphanage. There, it is recorded that young Coco

learned to sew and improved her skills. At her age 18, she was self-reliant and she got a new job.

After many years of repeated challenges and failures, in 1910, she opened and operated a boutique in Paris selling high-end fashion clothes and accessories for women.[2]

An entrepreneurial designer Chanel's great business step deserves to be praised as the famous economist Joseph A. Schumpeter's theory of entrepreneurship.

Schumpeter's theory of entrepreneurship lies in the fact that the characteristics of the entrepreneur's mindset or behavior are very important rather than the size of capital and other physical resources, and the size of market.[3] This is different from the economic growth theory of classical economists, who prioritized physical resources over human resources as well as the three factors of production such as land, capital and labor.

As everyone knows, since the decade of development like the 1960s, Korean economy has achieved rapid growth that can only be measured on a cosmic scale. And in May 2021, as the declaration announced by UNCTAD of the United Nations, Korea entered the world's first developed country from an underdeveloped and middle-income country.[4]

Such economic development and its growth was a unique path of economic development based on labor and human resources. In addition, it is also true that the growth engine was driven by Korean entrepreneurship.

The power of entrepreneurship is embodied not only in the national economy but also in the management performance of a company. Rather, the growth of companies through entrepreneurship is the driving force behind the growth of the national economy.

The virtual meeting between fashion biz leader Chanel and an economist Schumpeter that transcends time and space was quite fantastic.

Now, when looking at the history of fashion in the progress of human culture, Chanel's new path should be interpreted as the dawn of a great fashion revolution.

In this way, the fashion revolution revealed several changes in the social and economic structure and the syndrome of its innovation.

Firstly, production and trade of fashion products have undergone a change in structure and framework from a self-sufficient and family labor-incentive activity to an entrepreneurial fashion industry that pursues profit-seeking mass production.

It is because the trend of fashion is no longer the ex-

clusive property of kings, aristocrats, and the luxury class, but is leading a economic modernization that spreads into the lives of the general public. In fact, many fashion products have started to show off the income and wealth of ordinary citizens rather than revealing the status of the powerful class.

The fashion biz led by a designer as an entrepreneur has continued its revolutionary steps while being influenced and fed back to the process of modernization of the global economy.

From Opulence to Elegance

Needless to say, the history of human started when we began wearing clothes. Thus, the history of fashion can be traced back to the earliest days of human history, when clothing was typically made of plant, animal skin, and bone.[5]

Actually, the history of fashion based on new designs and sewing began in ancient Rome and Egypt. Someone said that there are traces of the beginning of this fashion history in ancient China and other Asian countries. Of course, there will be more discussion about the history of fashion.

In this human culture, clothing and fashion were symbols of the status of the people who wore them. Those who were wealthy would wear expensive and stylish garments that were colorful, while the poor would wear colorless and their garments were cheap but useful.

At first glance, prior to the 19th century the division between 'haute couture(luxury fashion)' and ready-to-wear did not really exist.[6] Logically, after the 19th century, discussions about the father of fashion Charles Frederick Worth and its mother Jeanne Lanvin followed.

On the other side, a small boutique in Paris, where we disccussed earlier was the epicenter of the fashion revolution. There, Chanel introduced fashion products with novel designs, so many women were able to wear casual clothes from corsets, which were uncomfortable for women because they were too tight.[7]

People are praising Chanel as an epoch-making figure who opened the history of fashion and contributed greatly to the women's liberation movement.

As an icon of fashion design, Coco Chanel created an opportunity that gave women the freedom to wear nice and comfortable clothes.

"The starting point of her design innovation was created a modern, and powerful women, largely independent from man and free in clothes."[8]

As discussed in Richard Thompson Ford's book 'Dress Code (2022)', Chanel's business moves are also a step and process of a great fashion revolution that transforms from opulence to elegance.

In this book, Professor Ford discusses how the law of fashion made history. After publication of this book, British journal 'The Economist' gave a review as follow.

"Dress Codes shows how fashion can both reflect and shape society."[9]

In particular, professor Ford's discussion of the process of the fashion revolution and its influence, which has been transformed from opulence to elegance, is very interesting.

In his discussion, the two terms, opulence and elegance, are similar but have different meanings. Opulence refers to the style that shows the wealth and luxury of kings, nobles, rich people, and their families.

Unlike the display of wealth or extravagance, elegance comes from manufacturing and shipping more graceful and stylish fashion products to the market.

Of course, the fashion revolution of Chanel style, which was implemented from opulence to elegance, did not happen overnight, but took place in the process of global modernization.

A movie we recently watched, the Netflix film(Mrs. Harris goes to Paris, 2023) also directed a story of Dior's management and marketing innovation.

After the death of the founder in 1957, the big com-

pany Dior predicted a new era in fashion marketing in response to young consumer resistance to the opulence era. In fact, by the early 1960s, New Look's collections and purchases from Dior had declined.[10]

The long journey of many fashion brands that transitioned from opulence to elegance took place in modernization. A columnist for Business of Fashion said.

"I love fashion and I used to able to justify spending money on it because I could tell people that luxury brands were so much better quality. But I can't do that anymore. And that makes me quite sad."[11]

In this view, it is undeniable that the quality of luxury brands has greatly improved through technological progress, such as better fabric and parts, design and sewing, and style. On the other side, it is also right that prices have gone up, but the quality has come down relatively.

In any case, luxury brands today are treated as hard-to-purchase fashion products by ordinary middle-class consumers, like fruits in the painting. To that extent, it is true that the market size is relatively reduced without an increase in consumer demand for luxury brands.

Luxury brands these days seem to be shifting from elegance to opulence, as if going back to an era of priv-

ilege and aristocracy.

It also served as a catalyst for the progress of the fast fashion era, which has grown into a popular fashion market.

We know well that any item of luxury goods has a high price elasticity of demand because that's sensitive to price changes. The problem is that as the prices of many fashion brands rise rapidly, they are starting to be turned away from elegance-oriented consumers.

In this way, huge number of middle-class consumers will be confused by their love and hatred for high-priced fashion products that have the brand image of fruits in painting, and the aftermath will lead to a failure of the market.

Fast Fashion and Market Failure

As we all know, fast fashion has been trying to increase consumer satisfaction by selling stylish fashion products at low prices at SPA-type retail stores such as Zara, H&M, and UNIQLO.[12] When the first H&M location in the U.S. opened in April 2000, the New York Times wrote.

"Chic to pay less."[13]

The press commented that the retailer had arrived at the right time as consumers had become more likely to hunt for bargains and dismiss department stores.

These new products led the fashion revolution as an alternative to the increased social cost of luxury fashion and were loved by many consumers. Thus, for a while, global SPA brand companies achieved remarkable management performance and rapid growth followed. However, the era when these SPA brand companies made a lot of

money was too short.

Rather, they were placed at a turning point of a new fashion revolution with the brand's life-cycle shortened. So now, those fast fashion companies are constantly facing a business crisis and are inevitable from social criticism.

"We know that H&M, one of the global SPA brands has been in a crisis due to the Amazon effect. But, the crisis of this company is the result of lack of sustainable management."[14]

The media criticism is spreading to all other global SPA companies like Zara, UNIQLO, etc. As well as, the criticism of these global SPA brands is not over.

As we consider it more deeply, the global SPA brands are facing another crisis.

SPA brand products such as Zara, H&M, UNIQLO have gained popularity from consumer in the global market. But that's not so 'fast'. Rather, most of them were products of poor quality or slow speed as a by-product of the old mass production era.

Now it is a new era of producing small quantities of various products to suit consumer preferences. Many consumers do not like fashion products manufactured using automated machinery. They prefer handmade fash-

ion products rather than machine-made ones. We remember such a proverb like "There is no accounting for tastes."

Tadashi Yanai, CEO of UNIQLO, said "Our company is not a fashion company, it's a technology company."[15] His confession is right.

In fact, a global SPA brand made a new entry into the market to sell stylish fashion products at low prices, but its life-cycle was very short. This is a point I would like to repeat.

Above all, the lack of novelty and diversity caused market failure without maintaining the image of fast fashion products. In the end, the global SPA brand could not prevent the distortion of fashion history going backwards 'from elegance to opulence.'

Lots of global shoppers are losing the way of where to go shopping. It is true that they have the right to pursue happiness by shopping for better fashion products at a reasonable price.

Didn't we say that happiness is not money but the pleasure of shopping? We can no longer ignore the numerous fashion consumers who have become depressed.

Fortunately, Dongdaemun fashion products will be a winner in the competition against global SPA brands, by

being 'faster and faster'.

Merchants in Dongdaemun market are proud to make and sell 'different' designer products or items with 'newness and its diversity' very quickly in 3 days at more than 30,000 stores.

As we knew well, any item of products has a life-cycle, just like humans are born, grow, mature, and age. In particular, in the case of fashion products, the business has a distinctive life-cycle, and its influence on commerce is remarkable.

Life-cycle of fashion products refers to the process by which a particular design, activity, color, etc. comes into some popularity and then phases out. It consists of five stages: the introduction, rise, peak, decline, and degeneration stage. Some trends stay in the peak stage for much longer than others.

What is interesting about the fashion life-cycle is that every trend you can think of has fallen into these categories at one point or another.[16]

Among them, the second stage is the rise stage, in which trends pick up in popularity. Most of the time, trends grow an audience through working with influencers and other companies to further advertise and spread the word.

In this stage of growth and maturity, Dongdaemun merchants must continue smart production and shipment through rapid decision-making and products innovation. to extend the duration. In other words, it is necessary to continue the fast and fast strategic alternative as it is in the Dongdaemun-style of commerce. An American software engineer Kent Beck said.

"Make it work, make it right, make it fast."[17]

SeoulClick CEO Lee Yong-woo said, "Our company is truly selling fashion products to overseas markets." This is because foreign buyers are trying to buy 'fast' fashion products that meet the needs of consumers while still being low prices.

This strategic approach seems to be based on the CEO Lee's management philosophy as follows.

"Merchants in Dongdaemun market should explore the way to 'export' for survival. All executives and staff members of SeoulClick, who have been doing overseas trade with customer service as the priority, are doing our best with a heart of 'sincerity' to overseas buyers. This is because the reality of the global market is that without sincerity, the desired commercial performance cannot be achieved."[18]

Flag of Fashion Revolution

For a while, global SPA brand companies like Zara, H&M, UNIQLO, and so forth was widely known as a profit-able business.

That SPA brand was popular with many consumer because it not only adapts quickly to changing trends, but also can be purchased at a low price. Maybe they got a good opportunity to shop for products of novel design at a low price instead of super-expensive luxury fashion that was nothing but fruits in the painting.

At some point, however, global consumers began to have doubts about their preference for SPA brands.

On April 24, 2013, in a city near Dhaka, the capital of Bangladesh, Rana Plaza, a clothing factory and commercial building, collapsed suddenly. At that time, the commercial building collapsed, killing 1,129 people and injured over 2,500 people.[19]

The collapse of the shopping center revealed the negative side of the global fast fashion business world, which continued to grow and boom.

The negative aspects of fast fashion were not only the environmental destruction caused by the mass production of low-quality products, but also the exploitation of labor and the deterioration of the working environment in the midst of clothing manufacturing factories in developing countries.

After the shopping center collapsed, as the negative side of fast fashion became known to the world, social criticism against fast fashion spread all over the world. Moreover, many global consumers have even advocated pursuing a new era of slow fashion instead of fast fashion.

This situation became the spark of the great fashion revolution from fast fashion to slow fashion. The advocacy and shouting of global fashion consumers sound like the song of the fashion revolution.[20]

"We love fashion. but the clothes we wear should never made by exploiting labor and destroying the global environment. We, therefore, widely demand reformative and revolutionary change. It is our dream."

The proposition that the fashion revolution aims for is

as follows. (1) Smooth circulation of resources, (2) Environment-friendly production and packaging, (3) Pollution reduction production, (4) Realization of a fair society and ethical management, (5) Manufacture of handcrafted products, (6) Quality improvement, (7) Pursuing the use of eco-friendly fabric and their parts, etc.

This is a strategic task to be done under the heading of the era of slow fashion. Such a slow fashion movement considers individual personality and taste rather than fashion, and its products must be traded more fairly.

In future, we must seek the practice of buying clothes once, wearing them for a long time, and repairing them.

"We are Fashion Revolution. We are designers, producers, makers, workers and consumers. We are academics, writers, business leaders, brands, retailers, trade unions and policymakers. We are the industry and the public. We are world citizens. We are a movement and a community. We are you. We love fashion. But we don't want our clothes to exploit people or destroy our planet. We demand radical, revolutionary change. This is our dream."[21]

We knew that they need our voice. The request they make as if in chorus continues. "We have no doubt that fashion has the potential to transform the world. We know from our experience over the past seven years that change can happen if we relentlessly speak out and call for action. The more people who sign this manifesto, the louder we all become and the stronger our shared vision becomes for a better fashion industry. Join us."

Until now, many fashion business leaders and experts have supported and encouraged the progress of the great fashion revolution, and actually made it their firm's management philosophy. And each of them welcomes events such as the recent Fashion Revolution Week.[22]

"Between 22nd and 29th April 2023, we celebrate Fashion Revolution Week."

"Supporting sustainable brands who offer an alternative to fast fashion is key to transforming the fashion system. Taking the time and shopping mindfully saves resources and eliminates hasty investments. Only buying what you need, wearing what you have for as long as possible, mending and recycling damaged pieces, thriving and exchanging are all revolutionary acts in a fast fashion system."

A decade later, they celebrate progress, but they also recognize that there is lots of room to improve. Of course, under the flag of the fashion revolution, it is true that discussions about the progress and tasks of the revolution have not stopped. It's something everyone should applaud. But we often learn the logic of the world by looking at the pure behavior of children as shown below.

"Children learn much more from how their parents or teachers act than from what they tell."[23]

As such, many fashion consumers and fashion business experts evaluate the company's fashion revolutionary and sustainable management itself rather than advertising or publicity of any fashion company.

Dongdaemun-style of Entrepreneurship

The flag of fashion revolution, such as slow fashion, raised due to the increase in social costs of global fast fashion, did not appear yesterday or today.

Going back half a century, there is a history of fashion revolution that could be a great turning point even if it is not widely known to the world.

In the early 1970s, the heroic activity and sacrifice of a fashion revolutionary, Jeon Tae-il, was shocking news comparable to the epochal fashion revolution that took place 100 years ago. At that time, a young sewing worker Jeon Tae-il shouted loudly in the voices of his colleagues at a marketplace.

"Comply with the Labor Standards Act. We are not machines. Let rest us on Sunday. Do not overwork the workers."[24]

As the Bible says, "His voice was the voice of God.

Because that's the voice of people." Until the day of his death on November 13, 1970, Jeon Tae-il, a worker at a sewing factory in Pyeonghwa market, demanded improvement of low wages, and difficult, dangerous and dirty working condition or environment. But, no one listened to his small hopes and cries for survival.

The night before the last day, he wrote the following bloody feeling. He was probably very heartbroken during a long and desperate night. For us, it is impossible to imagine every moment at that time.

"To the side of my poor brother, to the hometown of my heart, to the side of a child's heart in the Pyeonhwa market which is all my ideals, I swore for my life, in a lot of time and space, the weak creatures I have to take care of, I throw me away and kill myself. Everyone be patient."[25]

On the Cheonggyecheon road in front of the Pyeonghwa market, he sprayed gasoline on his body and set himself on fire, suffering from the heat. At that moment, he is said to have left us his last words in such a slender voice.

"Do not let my death be in vain."[26]

Despite the precious sacrifice of Jeon Tae-il and his death, however, many sewing workers in the Pyeonghwa

market have consistently received low wages in dirty, difficult, and dangerous working conditions.

Fortunately, after the progress of democratization through the 6.29 Declaration in the summer of 1987, the Korean economy faced an opportunity to improve the quality of working life, including guaranteeing the so-called 3 rights of labor, such as the right to organize, the right to collective bargaining, and the right to collective action. At that time, the sewing workers in Dongdaemun market also benefited from the policy of guaranteeing their rights, such as an increase in wages.

Earlier, Jeon Tae-il called for sustainable management such as payment of appropriate wages for any fashion business company. With the wisdom of seeing the future, he pursued a sustainable fashion business that we are interested in today.

Jeon Tae-il is still alive at the Dongdaemun marketplace. Sensing his breathing, the people of the marketplace are conducting future-oriented commerce.

Recently, fifty years after he left us, the Jeon Tae-il Memorial Hall was built in a fairly large building overlooking the Cheonggyecheon stream in Seoul. The Cheonggyecheon water flows eastward through Dongdaemun market and flows into the Han river, re-

minding us of the history of Dongdaemun market along with the legendary story of Jeon Tae-il.

Like a phoenix, Jeon Tae-il who burned his body and left was reborn from the ashes for the sustainable management of Dongdaemun fashion and the improvement of the quality of working life there. There, the Memorial Hall is his home, where his invisible body and spirit are together.

"Now, the beautiful young worker Jeon Tae-il is coming back to life. His love, solidarity and action are reviving. The Memorial Hall where Jeon Tae-il lives and breathes will become the symbol and center of union city Seoul. It will be an educational place of labor rights for many students and workers. It will become a cultural center where all of our citizens realize the value of work and understand and learn the meaning of work."[27]

Even now he is right. Today, many fashion companies are pursuing customer satisfaction management. In order to achieve such a management goal, however, it is necessary to provide employees with a lot of satisfaction in their working life in order to motivate them to work. In doing so, their companies will be able to operate sustainably.

Our hero, Jeon Tae-il, said that he had a big dream

of starting a fashion business company, 'Taeil Cloth', and doing sustainable management. It is a document exhibited at the Jeon Tae-il Memorial Hall.

"Taeil Cloth went beyond complying with the Labor Standards Act to protect workers by providing educational opportunities, and even advocated an equal distribution of profits. The various business plans that Jeon Tae-il had envisioned to realize this were the products of observation and experience, and included measures to improve the chronic problems of the Pyeonghwa market. Of course, Jeon Tae-il never got an investment fund to set up a business."[28]

Of course, many small and medium-sized fashion business companies in Dongdaemun market are still unable to fulfill Jeon Tae-il's dream of such a sustainable management. In contrast, in today's advanced countries, sustainable fashion management by improving the quality of life of workers is inevitable.

Obviously, Jeon Tae-il's unfinished dream is still valid today. Because he has been resurrected and is with us, sustainable management of Dongdaemun fashion and its growth will inevitably be achieved.

Jeon Tae-il's heroic behavior is Dongdaemun-style of fashion entrepreneurship.

<Notes>

1 The Lives of 50 fashion Legends, Fashionary, 2018.

2 www.google.com

3 Joseph Schumpeter, Economic Development, Harvard University Press, 1936.

4 UNCTAD, homepage, May 22, 2021.

5 google.com/article/the-history-of-fashion

6 Ibid.

7 Ibid.

8 https://leverageedu.com/blog/lessons-from-coco-chanel/

9 The Economist, Richard Thompson Ford, Dress Codes-How laws of fashion made history, Simon & Schuster Paperback, 2021.

10 instyle.com/fashion-history-of-

11 fasinbrands.com/article/why-is-luxury-fashion-experience

12 fashionista/2016/06/what-is-fast-fashion

13 Ibid.

14 Bong (Bong-sik) Sul, Fashion Marketing (Korean version), k-ebook, kstudy.com, p.185.

15 store-kr.uniqlo.com

16 Berkley Sumner, "The life cycle of a fashion trend, Cat Talk, January 2. 2021.

17 https://quotefancy.com

18 www.seoulclick.com

19 www.google.com

20 Ibid.

21 fashionrevolution.org/manifesto

22 www.milavert.com/blogs/news/fashion-revolution-week-why-we-need-a-revolution

23 Prime English-Korean Dictionary, 6th Ed., www.bookdonga.com, 1951, 2021

24 Jo Jung-rae, Jeon Tae-il (Revised ed.), Beautiful Jeon Tae-il, Yes24, 2021. www.taeil.org/information

25 Ibid.

26 Ibid.

27 Ibid.

28 Updates from Jeon Tae-il Memorial Hall

Part
3

Fashion and Supply-side Partnership

Dongdaemun Fashion Cluster

"Like the life-cycle, it is the natural law that new things get old."

As the saying goes, economic phenomena such as market mechanisms and commercial behavior are also the same. Dongdaemun market has been constantly innovating due to rapid changes in the business environment. It was a process of innovation for survival.

Founded in the early 1960s, Pyeonghwa market was the first step in an innovative business that 'produces and sells' the variety of apparels. The business system of Pyeonghwa market that produced and sold those products in one place can be seen as a childhood of the Dongdaemun market today. In other words, this start-up is like seeding in a field to get some fruit.

Since then, Dongdaemun Shopping Complex which established in 1970 as the largest in Asia, has been sell-

ing fabric and parts in one marketplace. Needless to say, the Dongdaemun Shopping Complex is also a favorite place for many domestic and foreign designers, employees of sewing factories, wholesalers and retailers, and buyers.

"What we are amazed at is 'manufacturing speed' of Dongdaemun fashion products, but it is also wonderful to sell fabric and parts in one place that enables 'rapid speed'."[1]

Lee Yong-woo, CEO of SeoulClick, an export agency of Dongdaemun fashion products said that it is a word often heard from overseas buyers. In the 1990s, Art Plaza pursued sustainable management of the market with business innovation and its strategic tools.

As everyone can see, fashion retailers in local regions as well as in Seoul operate during the day, so they do not have much time to go to the wholesale market for merchandising.

In this situation, Art Plaza changed the market opening hours from midnight to early morning for the convenience in transaction for local retailers, and attract chartered buses too.

With this change in thinking, most wholesale markets have increased business hours from 8:30 pm to early

next morning, providing convenience for local retailers and foreign buyers. The management innovation of this market has opened a main road to the magnificent Dongdaemun myth which has attracted people from all over the world.

Thanks to the so-called Dongdaemun Fashion Cluster, which was built through such a continuous management innovation, Dongdaemun market achieved qualitative as well as quantitative growth. Of course, Dongdaemun Fashion Cluster is a large-scale fashion business complex that produces and sells in one place and provides customer convenience with one-stop service.

Recently, the Dongdaemun Fashion Cluster, however, is experiencing a decline in the number of visiting retailers and overseas buyers. This was due to the growth of the global fast fashion firms and its competitive challenges, as well as the change of business paradigm from offline to online and the bottleneck of the logistics system.

As the situation changes, the Dongdaemun Fashion Cluster stands at the new big door to the 4th industrial revolution. The Cluster needs a strategic approach to new business systems such as mobile or omni-channel trading. A technical remark presented from a manage-

ment expert-like novelist is correct.

"Business has only two functions-marketing and innovation."[2]

Although it is not well known, Kmart in the United States was a big discount store until the 1990s. However, since the 1990s, Kmart has reduced its sales and number of chain stores, and Walmart has been ranked first in the world as well as in the United States.

At one time, everyone predicted that even if any big national economy collapsed, Walmart would achieve sustainable growth through innovation. After three decades, however, Walmart itself is moving toward new innovations in response to the challenge while increasing Amazon's market share.

Likewise, merchants in Dongdaemun are seeking a new way of innovation by reducing the transaction volume for local retailers and domestic and foreign buyers. In fact, merchants in Dongdaemun are launching a new strategy of online wholesale trading in Mobile era.

Such business innovation will probably contribute to the birth of the second Dongdaemun myth. This is exactly the change that people want.

"Innovation is needed for all firms and it is the busi-

ness itself. The management performance of a company is greatly influenced by progress and revolution, change and reform, and the durability of the change. More specifically, there are many ways to improve quality, reduce costs, strengthen market competitiveness, and realize economies of scale and scope, and so on. But in short, the measure of business performance depends on 'how new it is'."[3]

As the World Bank President A. W. Clausen discussed innovation as a process to renew, to begin, to start fresh, merchants in Dongdaemun market are constantly looking for a path towards innovation.

In a Netflix movie I recently watched, at the end of World War I, a British army commander exclaimed to his blood-like men. Rather, the appeal was a cry.

"We have come to this battlefield for the honor of our country, for the lives of our families, and for their safety. But here and now, let's all unite and fight for each other."[4]

People say that the whole is greater than the sum of its parts. Someone said, "We are no wiser than all of us."[5] Maybe this kind of good words are not heard well by busy and difficult people.

The Dongdaemun Fashion Cluster should find a sol-

ution based on the situational awareness that 'to be or not to be' is a problem, rather than understanding the beauty of partnership.

The Circle of Safety

As we all know now, many fashion companies are facing great difficulties due to the crisis situation inside and outside those companies.

The factors of the management crisis vary from company to company, but there are many and many. On the other hand, the solutions are also various and many. However, it is clear that even in the midst of chaos such as war in which lives and property are lost, there are always opportunities.

Although it is forgotten, Aesop's stories in the 6th century BC about 'Four Oxen and One Lion' exists.

One lion saw four oxen in a field. The lion then attacked the oxen several times. Oxen defended against the lion's a strong attact, with the tails touching each other and drawing a round circle. They resisted the lion's attack with their horns.

The oxen in the story were able to keep every ox alive by protesting together and resisting the lion's attack together. If the oxen "cannot resist together" and disperse and find themself way to live, all four oxen become food for the lions.

We say often that "We repair the stall after losing oxen."[6] The lesson of the story is that, the fence was not a protective wall.

As Simon Sinek claims, oxen were able to avoid the lion's strong attack with 'the Circle of Safety.'[7]

Dongdaemun Fashion Cluster has overcome the crisis by having partnerships with wholesalers, designers, executives & employees of swing factories, and others.

Of course, the American proverb "There is safety in numbers." is also right.[8] However, Dongdaemun market has been sustainable management thanks to the circle of safety created by four oxen.

A McKinsey report discusses the same implications of the circle of safety.

"Fashion supply chain management is characterized by an increasing global competition and pressure to improve quality of products, and respond quickly to changing customer needs with a shortened products' life-cycle."[9]

This is a widely accepted discussion. In fact, many

fashion business companies today have a number of business strategic tasks, such as intensifying global market competition, increasing market pressure for quality improvement, and responding to rapid changes in consumer needs and preferences. It is like a response to the kings of the jungle and forest, such as lions and tigers, approaching and looking for opportunities to attack ox or deer.

The problem is that weak animals such as ox and deer run in groups, and if one of them leave the group, there is a risk of being attacked by wild animals.

Likewise, fashion business firms in the market must help each other and overcome the crisis together. The marketing strategy of Dongdaemun Fashion Cluster, where they do business together, can achieve management performance while minimizing costs.

In the short term, there are many management difficulties, such as low salaries of designers, low wages and low sales of employees of sewing factories, low-priced sales of fabric and parts, as well as low distribution margins and low level of revenue for wholesalers.

In the long run, however, all Dongdaemun merchants and their partners get greater management performance thanks to long-term contracts and satisfaction of domes-

tic and foreign customers.

In addition, the quality of Dongdaemun fashion products is further improved through friendly competition between partners, the accumulation of trust, and the advantage of long-term contracts, and in the aftermath, it is giving satisfaction to domestic and foreign buyers.

The godfather of the world's automakers, Henry Ford, said, "Coming together is a beginning, staying together is progress, and working together is success."[10] Steve Jobs also left his own quote.

"Great thing in business is never done by one person. They are done by a team of people."[11]

Simon Sinek's book "Leaders eat last" we are discussing now explains the concept of 'the circle of safety.' Likewise, we also discussed keyword 'the circle of safety' as Dongdaemun-style of fashion biz. Its logical validity is simple.

"When we are in the circle of safety, we will be able to achieve sustainable management performance as a team even in any crisis."[12]

We need to recognize the law of iron that if that circle is broken, the global market competitiveness of Dongdaemun fashion established through partnership will

be weakened. Alfred A. Montapert left a quote that we can all accept.

"All lasting business is built on friendship."[13]

The significance of such discussions is that the Dongdaemun Fashion Cluster, like a circle of safety, must be operated properly. Anyway, when all the people in the market are more altruistic like brothers than friends, they will all be able to achieve great management performance.

Dokkebi Market

"In a bright day, no one appreciates the light. In the dark, however, less bright light is visible. It is because of darkness."[14]

Because Dongdaemun market is open for wholesale trading at night, people call it the Goblin (Tokkebi) market. The pretty words of a novelist quoted above were also obtained through a search for the keyword 'Tokkebi'.

Most foreigners are unfamiliar with the Tokkebi market, but it is quite an interesting marketplace.

Legends about Tokkebi handed down from ancestors are interesting and even familiar. That very Tokkebi only appears in the dark night, and its lights are quite fantastic. In the morning when the sun rises, however, the Tokkebi lights disappear.

In the old days, Koreans used to believe in the

"miracle of the Tokkebi bat" that happened in the legend. Like a Genie in the Arabian Nights, the legend of Western countries, the Tokkebi bat had magical powers. This is because it was believed that if someone shouted "Gold come out!" with the Tokkebi bat, the poor would be blessed with money, wealth, and grain, etc. to become rich.

We are sure that anyone can possibly have such legendary Tokkebi bats in Dongdaemun market. Maybe everyone wants to have that kind of luck. As the English proverb goes, is there luck in leisure?

In any case, Dongdaemun market deserves the nick-name "a phantom market," that is, the Tokkebi market. This is because the market opens at 8:30 p.m. to conduct wholesale transactions and closes the next morning.

The light of the Tokkebi, like the legend, is not so bright because it is momentary. Likewise, the outside of Dokkebi market is not so bright. After opening every wholesale store, however, the inside of the market is surprisingly brighter under the LED light.

Moreover, the interior of the market is brighter than in broad daylight, and even more dazzling than the daytime, in combination with colored items such rainbow-type

accerssories. So many domestic and foreign retailers and buyers have said.

"Dongdaemun market is crowded with people at night than during the day, and everyone in the marketplace is lively."[15]

In this aspect, Dongdaemun market is a unique marketplace that stays awake by producing and selling various fashion products all days.

As such, the Tokkebi market, where commerce is conducted during the night when everyone else is sleeping, is a marketplace of hard work like Koreans. One paper on "A Sociological Study on Koreans' Diligence" discussed as follows.

"The diligence unique to Koreans has been widely explained socially and culturally as an important topic of discourse from self-development to economic growth and quality of life."[16]

As we all know, the Korean economy has been a so-called 3D industry avoidance phenomenon in which many people avoid difficult, dangerous and dirty work in the process of post-industrialization since the 1990s.

In response, the people of Dongdaemun market remain in the workplace where the ecological rhythm is twisted on sleepless nights. They may take on a task

that is harder than the pain of the 3D industry in the industrialization era. And, they have been working hard in the field of life with sweat and tears.

Nowadays, they are still working silently in the new 3D industry with hope for a bright tomorrow under the banner of "Let's live better!" SeoulClick executives and staff also go to work at 9 am, and some of them are working at Tokkebi market until midnight.

SeoulClick, with its purchasing team and sewing technicians, offers a variety of purchasing services including inspection, repair, packaging and delivery of products purchased in the Tokkebi market.

Despite the unprecedented market crisis, there are many small but strong Dongdaemun merchants and their companies.

Everyone in the Dongdaemun market is looking forward to a busier marketplace as they target the global market, possibly going into the future, where the scale of online and un-tact commerce is rapidly increasing.

Recently, the mascot DD has been widely released in Dokkebi market. This is a good word that everyone will be interested in.

As anyone can understand, the designation of these mascots is one of the marketing strategies to expand the

brand awareness of an item of products and increase sales of the products.

It is similar to the logo, but different. Any logo usually gives the company a name, but the mascot gives the products or company a character. Such a mascot can be anything from anthropomorphic animals or objects to cartoon depictions of humans or even actors pretending to be actual people. Someone's discussion of brand mascots is quite convincing.

"A brand mascot can breathe new life into your business. Leverage this powerful tool to expand your brand and reach new demographics."[17]

As such, it is worth discussing that the mascot is the face of a company and a competent salesperson. It is a means of cost-saving management, and is also a brave soldier of online and un-tact management.

Although the birth of the mascot DD is late, it is a celebration that brings bright hope to Dongdaemun merchants who are in despair and frustration amid the disaster of the corona pandemic.

This mascot was created with a talent donation from the author The betterna, who is currently working in Germany. As an impressively known rumor, the mascot DD, led by Dongdaemun Vitality Center, was created

in anticipation of the Dongdaemun market people performing dynamic business activities such as blue color amid the current difficult management crisis.

Dongdaemun Vitality Center, CHO Hyunmin (Yulria) explained the image of the mascot DD as follows.

"The mascot DD contains dignity and loyalty of the merchants who wake up in the morning with the fresh air of the blue dawn."[18]

First of all, the mascot 'DD' embodies the hopeful faces of Dongdaemun Domaesang (wholesalers). Those Dongdaemun wholesalers have been doing business hard during the night when everyone else was asleep for the convenience of commerce for domestic and foreign fashion retailers and buyers.

The mascot DD, which was created and appeared ambitious, will bring richer management performance as a reward for the good and diligent commercial activities of Dongdaemun merchants, just like the Tokkebi bat.

We hope that all Dongdaemun wholesalers will wear this mascot DD as a mark on all excellent fashion products they design, manufacture and sell, and use that more in advertising and promotion. The mascot DD is the face of the Dongdaemun market, a salesman approaching customers, and a true Dongdaemun merchant

who communicates and provides services with more domestic and foreign buyers.

Such mascot DD and its strategic tooling will help to form a brand image of Dongdaemun fashion. People believe that brand image is very important in any business. This is a discussion in Forbes.

"Brand image is important for any business. When consumers buy a commodity or service, they aren't just buying such a thing; they're buying what your brand stands for. That's why it's so important to design your brand image to convey exactly what you want it to say."[19]

As an avatar of Dongdaemun merchants, the mascot DD will always be what the heart thinks, the mouth speaks.

Supply Chain Management

We often discuss whether the source of any item of fashion products is a design lab and a sewing factory, or a market to meet consumers. The issue of debate is whether it is a push on the supply-side or a pull on the demand-side. In fact, it differs depending on the point of view.

Of course, designers' creative designs, production in sewing factories, and supply and shipment to the whole-sale market are made according to the consumer needs or preferences, and their desires. Some of suppliers, however, act as a driving force to stimulate and induce fashion consumers' preferences and willingness to buy.

In Dongdaemun market, many designers, entrepreneurial wholesalers, and many small and medium-sized sewing factories scattered in Gangbuk, Seoul, as well as huge number of fabric and various fashion parts shops, are

focused mainly on supply-side management.

The people of Dongdaemun market are running wider supply-side management together and separately. They are partners, but sometimes competitors. Business behavior between these partners is quite positive. All right. Not only the cooperation between them, but also the competition of them is making a remarkable contribution 'to supplying good fashion products at lower prices.'

Among them, Dongdaemun wholesalers have amazingly multi-fuctional power to pursue creative designing, prediction of fashion style and its trend, and adoption of rational marketing strategies. According to one argument, Dongdaemun designers make such management decisions as CEOs while owning one or more wholesale stores.

"Dongdaemun designers are increasing the management performance of wholesale commerce by playing various roles as CEOs such as creative design, products' output planning, brand marketing, and MD of diversity."[20]

As a designer, wholesalers are also play roles as researcher, manufacturer, entrepreneur, and problem solver, and so on. In particular, their supply-side management like SCM is quite excellent.

Here the keyword Supply Chain Management (SCM) is not a new terminology. In supply side, it is a man-

agement system that rationalizes the flow of products between producers and wholesalers or retailers.

In general, the strategy of SCM can achieve various management performances that could not be expected in traditional business systems. This management strategy can reduce inventory costs and shorten lead times by maintaining optimal volume of inventory. This strategy can also increase the efficiency of various other tasks, and eliminate wasteful input of material and human resources.

Particularly, electronic supply chain management (e-SCM) appears due to the emergence of the Internet and informational communication that enabled companies to be more responsive to their trade partners. The advantages of such a SCM are no different from the case of SCM in Dongdaemun market.

In particular, the e-SCM has achieved better management performance, such as faster decision-making of supply-side management, smooth communication with trading partners, and appropriate realization of the transaction, thanks to the innovative operation of the Internet and information communication.

With SCM's strategic tool, Dongdaemun market continues its unique supply-side management.

"Fashion supply chain management is characterized by an increasing global competition and pressure to improve quality of products, and respond quickly to changing customer needs with a shortened life-cycle of products."[21]

In fact, the Dongdaemun market's SCM strategy is contributing to the rationalization of fashion products' design, fabric and parts procurement, and sewing and trade or logistics services.

The SCM strategy in Dongdaemun market is to manage the supply for fabric and parts, manufacturing and trading fashion products, and physical distribution.

When one thinks about it, merchants in Dongdaemun market do not sell products, but they are doing a great job in producing and supplying so-called customized products that customer wants and needs. Maybe, Dongdaemun market is not only the marketplace that 'sell fashion products' but it is a place to 'produce and supply the commodities' that customer preferred.

On the other hand, Dongdaemun merchants, who do supply-side management in this way, cannot neglect the smooth communication with demand-side partners such as domestic and foreign fashion retailers, buyers and their consumers, as well as the supply of better products

and the provision of its services. There is a proverb that is often spoken among merchants.

"No customers will kill us."[22]

Without customers, there is no design, no manufacturing, and no sales. Therefore, the customer is the key to the survival and prosperity of supply-side business people.

The famous French economist Jean-Baptiste Say said, "Supply creates its own demand." This is the basic theory used in economics textbooks.

Likewise, when any company produces fashion products with good design and quality and supplies them to the market, consumer demand is induced to purchase them.

Regardless of any supplier, it should always be remembered that customers want to enjoy satisfaction with better products and services.

McKinsey & Company also pointed out that a demand driven & flexible supply chain is more important than ever. In a market crisis like frozen ground, producers as well as their wholesalers and retailers, must play such an important role together.

Needless to say, the people of Dongdaemun market will have to put all their energy into selling better fash-

ion products that suit the needs and wants of consumer at lower prices while continuing to manage the chain of supply side as they have done in the past.

Pearls in the Mud

"You know what. A lot of people are mining pearls in the mud at the night market."

Perhaps everyone will say quite surprised, "Excuse me. What do you mean?" But that's true.

Many domestic fashion clothing retailers and foreign buyers often go to Dongdaemun market in Seoul. They go from place to place in Dongdaemun market to buy better fashion products made by designers at lower prices.

In August 2018, a big data analysis on the image of foreign tourists summarized the responses to Seoul very effectively.

"Seoul is a youthful city, enjoying an evening with people and it is quite energetic."[23]

There are two notable landmarks in the Gangbuk area of Seoul. One is traditional architecture, Dongdaemun(the

East Gate), which was built in 1396 to the east of the old city of Seoul, and the other is ultra-modern architecture, Dongdaemun Design Plaza, which was designed and built in 2014 like a spaceship that landed some time ago.

Based on these two landmarks, Dongdaemun market is a world-class shopping district with over 30 markets and 30,000 shops in the markets.

In Dongdaemun market, there are many designer products of good quality, such as 'pearls in the mud' that many fashion retailers and buyers are going to mine.

However, it is not so easy for foreign buyers to choose 'good fashion products' in Dongdaemun market. Because Dongdaemun market is like a wide and jungle-style forest, it is difficult to distinguish lower priced better products among various merchandises in the marketplace.

Fortunately, in Dongdaemun market, there are companies that guide and support the purchase of fashion products. Among them, SeoulClick is a trading company that provides services to help mining pearls in the mud.

SeoulClick provides a service that purchased by proxy, but also inspects purchased products, improves product

value by repairing defective products, and provides services like packaging and delivery, etc.

In fact, many overseas buyers are making a lot of money at SeoulClick by selecting cheap and good products and increasing the value of products through inspection, repair, packaging, etc.

Of course, if anyone goes to Dongdaemun market, they can meet some 'Purchasing uncle' there. However, most of them provide such services to domestic local retailers, but there are few services for foreign buyers.

In fact, amid the spread of global fashion management, market demand for fashion products such as pearls of the mud is rapidly increasing. Coco Chanel, the first queen of the fashion business world, left many famous quotes. This is also the reason why she is still widely loved.

"One of the famous pearl lovers in the world, was the designer who first introduced pants for women, as well as the one who launched the first designer perfume."[24]

Many designers working in Dongdaemun market have a professional mindset thinking about how to give shopping satisfaction to many domestic and foreign consumers according to the changing trends.

Doris Lessing, a British writer who won the 2007 Nobel Prize in Literature, left us about 10 years ago, leaving behind a short quote of her own.

"Pearls mean tears."[25]

The pearl, buried in the cold and suffocating mud, gains freedom from being held in the hands of a beautiful woman and hung around her neck, revealing her beauty. Likewise, the people of Dongdaemun are in a sweat to manufacture and sell fashion products such as pearls.

Needless to say, it is also true that pearls in the mud have different emotional values depending on who wears them around their neck.

There is a saying that we widely agree on. That is as follows. "It takes all sorts to make a world."[26]

There is no doubt that Dongdaemun market is a world. Namely, that's the world of fashion business. In this world-class market where fashion products like 'good brand for less' are supplied, many domestic and foreign merchants will achieve greater management performance.

<Notes>

1 www.seoulclick.com

2 Milan Kundera, novelist, Johnnie L. Roberts, The Big Book of Business Quotations, Skyhorse Publishing, p.283.

3 Sul Bong Sik, Innovation is the business itself (Korean version), IS Publishing Co. Ltd, 1991, p.47.

4 The Lost City of Z, Netflix film.

5 Bong (Bong-sik), Sul, Smart Management of Franchise Small Biz, CAU, 2013, p.97.

6 That's a Korean proverb

7 Simon Sinek, Leaders Eat Last (Penguin, 2014), pp.24-25.

8 Prime English-Korean Dictionary 6th ed., www.donga,com., 2021.

9 McKinsey & Company Report

10 google.com/search/q?

11 Ibid.

12 Bong (Bong-sik) Sul, Dongdaemun fashion and the Circle of Safety, M. K (newspaper), October 14, 2018.

13 www.google.com/search/q?

14 Cha Seung-hyun, "My son, your father is dreaming," e-book, google.com, 2012.

15 www.naver.com

16 Cho Jae-hyun Oh Se-il, "A Sociologic Study on Koreans' Diligence" KCI, 2017, pp.207-232.

17 medum.com, Rick Enrico, A brand mascot make your business more personable, May 2017.

18 D-Story, 2020. 12, pp.8-9.

19 Solomon Thimothy, "Why brand image matters more than you think," Forbes, October 31, 2016.

20 Hwang Ja-young, "Fashion designers' decision-making process," Graduate Theses and Dissertation, Iowa State University, 2013.

21 www.google.com

22 Prime English-Korean Dictionary, www.bookdonga.com, 2021.

23 www.naver.com

24 thepearlsource.com

25 www.theguardian.com/books/2013/nov/17/doris-lessing

26 Prime English-Korean Dictionary, 6th Ed., www.bookdona.com, 2021

Fashion Design and Midas Touch

Designing and the Midas Touch

Nowadays, many consumers tend to buy famous fashion products simply by looking at the logo or brand.

On the other hand, fashion retailers or buyers who frequently visit Dongdaemun market are trying to satisfy the consumer needs with the purchase of unique fashion products that suit the personalized trend according to consumer preference. Perhaps someone will ask, "Is that true?"

Unlike global luxury brands, Dongdaemun fashion products are manufactured based on the creativity of unknown designers, and the merchandising of shipped products is quite diverse. In terms of novelty, Dongdaemun wholesalers ship new products every 3-4 days. And, in terms of diversity, the products released by numerous designers are similar but completely different for each store.

In this regard, Dongdaemun fashion products have strong market competitiveness thanks to the creative design work of huge number of designers at each store.

We are sure that designers working in Dongdaemun market tend to induce demand for their customers by trying to increase the emotional value of their products. What they design and produce is called the designer's brand, and such work itself is one of the marketing strategies to enhance the emotional value of the products.

They have magical powers like the Midas touch, a legend that everything touching by the hand turns into gold. The Midas touch, one of the legends that laughed at human's relentless desires, makes us think about the true value of life and teaches us the code of conduct.

"The most famous King Midas is popularly remembered in Greek myth for his ability to turn everything he touched into gold. This came to be called the golden touch, or the Midas touch. According to Aristotle, however, legend held that Midas died of starvation as a result of his 'vain prayer' for the gold touch."[1]

Dongdaemun designers, however, are focusing on creating fashion products that suit the needs and preference of fashion consumer, rather than a touch for gold. As Michael Kros said, "Clothes are like a good meal, a

good movie, great pieces of music," the designers make more good clothes not gold.[2]

In fact, the continued growth of the Dongdaemun market and its business performance have been achieved by the hands of many designers increasing the emotional value of products designed with love and care for customer.

Here, we would like to attach the saying left by Steve Jobs, who is praised as an iconic businessman of innovation.

"Design is not just what it looks like & feel like. Design is how it works."[3]

So far, we have praised the passion of Dongdaemun designers and their diligent work, while criticizing King Midas's vain greed and his prayers. However, we may have all been acting and making mistakes like that king. Consider the issue Nick Herbert, member of House of Lord of the United Kingdom discussed here.

"Legendary King Midas never knew the feel of silk or a human hand after everything he touched turned to gold. Humans are stuck in a similar Midas' predicament: we can't directly experience the true texture of quantum reality because everything we touch turns to matter."[4]

Likewise, fashion is not just about making clothes.

Fashion, its history, began when we passed the era of simply 'draping' clothes and entered the era of 'tailing'. The famous saying of Sir Francis Bacon is more philosophical.

"Fashion is about turning a way of life into an art."[5]

The fashion design, however, is not simply a process of making clothes, nor does it pursue artistry while ignoring market trends. Rather than just vain dream of changing all materials to gold, we have to look at the harsh reality of the market and its trends.

We, or many Dongdaemun designers, will be able to design better fashion products and sell them by mastering 'the true texture of quantum reality'. So many fashion legends may have said "Passion is fashion."

Lee Yong-woo, CEO of SeoulClick, argued.

"When many Dongdaemun designers design better fashion products with passion, their products will become as valuable as gold and will be able to compete in the global market."[6]

Some argue that the competitiveness of Dongdaemun market is the fruit of the Midas touch realized in the busy daily lives of many designers.

They, designers' intellectual abilities and actions are factors for the stable growth of the Dongdaemun market.

Designer as an Entrepreneur

There are a total of 100,000 designers in Dongdaemun market. The designers include wholesale shop's associates and part-time employees, as well as freelancers and other apprentices.

As we all knew, the growth and stability of Dongdaemun market and its fashion cluster complex is continued by many human resources such as designers, wholesalers and retailers, and technicians of sewing factories. In particular, Dongdaemun designers are a more important human resource as they take the first steps on the long journey of manufacturing and selling fashion products, as well as purchasing and consuming them.

Many people recognized that a designer as a high-level human resource with an important role and various functions in running a fashion business. Any article points out them as folows.

"A fashion designer outlines, designs, and creates clothing garments. However, fashion designers don't just make clothes. They often apply cultural attitudes, aesthetics, and inspirations to their designs."[7]

The role of a fashion designer differs from company to company. But as an entrepreneur, a fashion designer needs two kinds of behavior like creativity with designing and art with commerce.

Designers as an entrepreneur, therefore, will have to look after everything, and take risks, and decide on what would work for a business, and what wouldn't.

As the fashion business itself is a 'people-oriented' industry, any designer needs to communicate more with more people and build more friendly relationships. In fact, fashion designers are working cooperatively with other individuals in the fashion business, like stylists, merchandisers, pattern makers, tailors, costume designers, modeling agencies, design firms, magazine editors, and more.

As an entrepreneurial designer, Coco Chanel was an exceptional woman who became one of the most influential designers in the fashion world, and eventually one of the most successful business women of all time.

Coco Chanel is a celebrity, just as Time magazine

named her one of the 100 most influential people of the 20th century. This praise is the same as mentioned above. In particular, she was a designer as an entrepreneur who left a big footprint that could be called a godmother in the fashion business world.

The legacy she left behind is the brand value of Chanel, which is exerting its power in the global market. Not only that, but her entrepreneurship, as well as many quotes such as gold and jade, is making a huge impact in today's fashion business world.

Chanel's management philosophy and its entrepreneurship differ from person to person, and there are many discussions about it. Among them, her code of conduct needs further discussion.

The first of all, "No negative self-talk." She said that success is most often achieved by those who don't know that failure is inevitable. She believed in herself beyond belief. She knew she was talented and had every bit of opportunity as the next person. She didn't let negative self-talk dictate her life.

"There is a time for work and a time for love. That leaves no other time."[8]

The secondly, she knew how to manage her time and energy to suit her own goals. She knew what was most

important to her and she neither deviated from that or tried to combine them all.

As a businesswoman, Coco wasn't one to waste valuable resources with endeavors that did not serve her higher purpose. Her only focus in life was her vision, her brand, her company, and occasionally love.

In this way, Chanel's mindset can be taken as a norm for the behavior of entrepreneurial designers in Dongdaemun market.

Fashion Design and Craftsmanship

As everyone knows, ddp is a proud landmark of Dongdaemun market. One year, at the ddp exhibition hall, anyone could see the works of the Kansong Art Museum, which holds some valuable cultural assets, such as the Hunminjeongeum Haeryebon, Admiral Yi Sun-sin's Nanjung Diary, Samgang Goryeo celadon, and Shin Yun-bok's Portrait of a Beauty, and so on.

Among them, the Samgang Goryeo celadon, a world-renowned exhibit, drew great attention from domestic and foreign tourists and shoppers. The cultural property displayed there, Goryeo celadon (Goryeo dojagi, also known as Goryeo cheong-ja) is one of the rare exhibits that are well known worldwide. A famous scholar of the Goryeo Dynasty, Yi Gyu-bo left a review on such the exhibit, Goryeo cheong-ja, as follows.[9]

"Blue as jasper, bright as crystal."

As impressed by what I saw and felt at the British Museum in London 44 years ago, Goryeo cheong-ja is still widely loved by people around the world. Needless to say, Goryeo cheong-ja seems to hold a mysterious beauty thanks to its iconic blue-green color and its perfectly balanced shape. The praise of Goryeo cheong-ja by the people of the Song dynasty in ancient China was surprisingly high.

"Jade-colored Goryeo cheong-ja is the best under heaven."[10]

From historical facts, the Goryeo cheong-ja, the world's first metal-type was the products of people's craftsmanship at that time.

When we say craftsmanship, it's high quality and its technique that comes from creating with passion, care, and attention to detail. And, high quality and its technique are valuable performances that are honed, refined, and practiced over the course of a career.

Craftsmanship is quite different from a few techniques of artisans' work. Artisans and craftsmen work in an artistic capacity, both creating items with their hands. In this discussion, artisans tend to work on more unique projects designed for aesthetic appeal while craftsmen master the creation of functional, mass-produced items.

Anyway, craftsmanship is the quality that something has when it is beautiful and has been very carefully made. Recently, craftsmen of this era have been recreating and producing immortal Goryeo cheong-ja in various places including Gangjin, Jeollanam-do, Korea.

With this craftsmanship, Dongdaemun designers are also reinventing and designing better fashion products, influenced by the pride of ancestors who made the cultural works, Goryeo cheong-ja. They are also patriotic Koreans, well-educated in history. Their thoughts and actions themselves are craftsmanship.

In fact, Dongdaemun designers live in difficult work environments such as low wages and hard work compared to famous designers in global fashion companies.

No matter how difficult the market situation is, however, they consider the designer job as a gift from heaven and are patient and working hard for a bright tomorrow. A Spanish designer, Cristobal Balenciaga said.

"A good fashion designer must be an architect for the patterns, a sculptor for the shape, a painter for the designs, a musician for the harmony, and a philosopher for the fit."[11]

This is a quote that we should consider as valuable as gold or jade, and it is a basic philosophy of Dongdaemun

designers' behavior and a guideline for design work. Perhaps it will be helpful to Dongdaemun designers in their creative work activities and their achievements.

On the anticipated situation after the 4th Industrial Revolution, we will often understand and discuss AI, automation, the end of hard work, etc. At that time, anyone might think that craftsmanship was not very important, and the market conditions of online and un-tact commerce could also be more generalized.

Paradoxically, however, the spirit of new age will re-invest in the forgotten value of craftsmanship, time management, accountability of customer satisfaction management, and overcoming uncertainty, and so on. In particular, there will be more re-awareness of the value of craftsmanship, more work to be done and more employment opportunities.

Dongdaemun designers are always awakened by inheriting the craftsmanship of their ancestors who manufactured valuable Goryeo cheong-ja.

As an Italian film director, Federico Fellini said, Dongdaemun designers should continue their fateful work under the belief that "Style is craftsmanship."[12]

The Designing Rule of Conduct

Next in Fashion (NIF) is a reality show and fashion design competition series debuting on Netflix in January 2020. Over ten episodes, eighteen designers compete in rounds based on design trends and styles that influence what people wear worldwide.[13]

The winner of NIF, Kim Min-ju is from South Korea and started her own label in 2014 with her sister who runs the business side of the brand. We were delighted with the news of her award and the birth of a new star.

Although the choice of patterns and colors is tricky, she seems to have been highly regarded for applying patterns and colors to her own style. The birth of such a star-class designer will give a stimulus to Dongdaemun designers.

In Dongdaemun market, there are many people who

design dreams. In other words, they want to be a famous designer and have a big dream of developing their own brand and becoming a wealthy merchant.

LinkedIn CEO Mushi Bhuiyan discusses the challenges many fashion designers face today. This is exemplified as follows.[14]

(1) difficulty in selecting target customers' preferences and styles,

(2) lack of AI and big data-based design innovation,

(3) lack of experience in fashion business that can adapt to rapidly changing market environments,

(4) Delay in innovation in sewing factories and low productivity of technical manpower,

(5) Lack of a fashion marketing strategy to adapt to the rapidly changing market environment,

(6) The weakening of price competitiveness due to the rise in production costs and wages,

(7) damage to the creativity of designers due to insufficient protection of intellectual property rights.

Designers' response to such a challenge will be to change the logical basis of their actions. In general, designers dominate the logical foundations of the right brain, such as music and art. On the other hand, the logical basis of the left brain, such as the management

mind and calculation, is relatively weak.

Therefore, Dongdaemun designers need not only accurate and detailed, but also a management mind equipped with the ability to plan and execute. A more concrete alternative requires designers to spend more time working in the marketplace, on the streets, and in the wide field of life, rather than spending all of their time working in the design studio.

Needless to say, any dream will come truly to those who work diligently. As we discussed with SeoulClick CEO & executives, dreaming Dongdaemun designers need to have three rules of conduct.

First, they must truly love consumers of fashion products. Dongdaemun designers should know what consumer needs and wants are and design their own fashion products on the basis of market information.

Second, they need to produce and supply better design products through constant research & development, trial and error, and improved competitiveness.

Third, it is important to wait. Dongdaemun designers, never give up! Then one day early in the morning, some on them will find themselves a star-class designer.

Unlike this discussion, any mobile report advises a great solution what a designer does is worth considering.

"Fashion designers hold a special place in our world. Their talent and vision play a big role in how people look, and also contribute to the cultural and social environment. They love to study fashion trends, sketch designs, select materials, and have a part in all the production aspects of their designs."[15]

Dreaming Dongdaemun designers should also listen to other advices. that is,

"By focusing on how an item of products will be made, how it will used, and what will happen to it afterwards, designers can un-lock the full value of clothing."[16]

In Dongdaemun market, designers are influential market people who determine the rise and fall of Dongdaemun fashion business. Their thought and actions are like a bright milestone toward the future of Dongdaemun fashion business.

We are sure Dongdaemun designers will come off with flying colors.

Every day is a Fashion Show

Recently, Seoul Fashion Week, which is held every year since 2000 has become widely known as world's top five fashion shows with collections in Paris, Milan, London, and New York.

Unlike previous years, the Spring-Summer 2021 Seoul Collection opened and reached consumers and fashion buyers around the world through an online platform due to the Covid-19 pandemic. In our opinion, such online fashion shows may become more common as the future of Seoul Fashion Week.

Such a fashion show is a strategic tool which cannot be overlooked in fashion marketing. Thinking about it, a fashion show is an event in which designers themselves communicate with customers while displaying new ideas through fashion products worn by several live models.

In theory, fashion shows can tend to be more conceptual and focused on a higher level of idea. One column continues this discussion.

"Whatever the fashion, it is the choice of customers whether or not to accept a trend. Thus, fashion shows are a tool the latest trend to show."[17]

The following Coco Chanel's quote that is widely shared, is the very best thing.

"Every day is a fashion show, and the world is your runway."[18]

Even if there are different interpretations of this phrase, the argument that we should dress well at all times is acceptable because the world itself sees us. A persuasive discussion on a certain blog continues. Just as clothes make man, our lives may be treated as the lord of all things because we can choose and wear clothes according to taste and preference.

Like the famous quote, it's not easy to hold a fashion show every day. In particular, in order to hold fashion shows every day, many human and material resources and a suitable business environment are required.

A global fast fashion company, Mango, with more than 500 designers has a management goal to discover more about the needs of its customers, understand their

expectation and their perception of the brand, and take their feedback into account in decision-making.

It is known that the designers of the Mango attend traditional fashion shows and fairs to prepare for frequent new products presentation meetings, and are analyzing and understanding its trend as follows.

"We will allow the brand to creative disruption and novel initiatives and services which are aligned with its customer vision and respond to their new needs."[19]

It is true that it is not well known, but Dongdaemun market has an advanced human resource with much more designers than most global fashion companies. Their creativity, power of information gathering and design development are particularly worthy of boasting.

In addition, they have a strong desire for success, and although there are various practical difficulties, their will to live is especially a great weapon to improve their market competitiveness.

But many designers are neglecting to be together. That's one of the big problems. Like the frequent meetings held at the Mango Design Center, Dongdaemun designers should also hold frequent meetings to focus their efforts on exchanging information and discussing and competing for design development in good faith.

For any business, the strategic alternative must be found inside and outside the market. As we all know, we think of the market as a place to buy and sell all kinds of products. The very meaning of the market is that it is a place where sellers and buyers meet each other, and it is also a place where various kinds of market information are exchanged. Let's read the quotes from fashion legend Coco Chanel again.

"Fashion is not something that exists in dresses only. Fashion is in the sky, in the street. Fashion has to do with ideas, the way we live, what is happening."[20]

Even if her quote is different from reality, go at once, or Dongdaemun designers will be late. Of course, in Dongdaemun market, there is no fashion shows and catwalk of the models at that time. Nothing is also the search light there.

Instead of the visible fashion show, Dongdaemun designers will be able to get valuable information about the various fashion consumer preferences and the reactions of supplier in the market. On this valuable foundation, they may be able to do better design work while adapting to the latest trends.

\<Notes\>

1 www.google.com

2 brainquote.com/author/Michael-Kors-quotes

3 google.com/search/q?

4 Ibid.

5 quotestats.com/topic-about-midas-touch

6 www.seoulclick.com

7 www.masterclass.com/articles/how-to-become-a-fashin-designer

8 leverageedu.com/blog/lessons-from-coco-chanel

9 Ministry of Sports and culture (homepage), Korea

10 koretourinformation.com/blog2013/12/05/timeless-beauty

11 azquotes.com/author/23642

12 en.wikipedia.org/wiki/federico-fellini

13 Korea Times, October 7, 2021.

14 www.linkedin.com/pulse/prospects-fashion-desgner-major-challenges-faces-mushi-bhuiyan

15 www.careereplorer.com/careers/fashion

16 www.weforum.org/fashion has a huge waste

17 fibrre2.fashion.com/Influence of fashion shows on the fashion market and society

18 www.google.com/search/q?

19 press.mango.com

20 www.google.com/search/q?

Part
5

Fashion and Smart Factory of Sewing

Every Little Bit Helps

There is a proverb in the widely accepted English version.

"Every little bit helps."

Synonymously, Koreans often say that when dust is collected, it can become a high mountain. In the process of development, several trash landfills in the suburbs of Seoul have become quite high like two or three mountains after 20-30 years.

Anyway, Dongdaemun market is a large shopping mall that is hard to find in the other countries of the world. The market is famous for merchandising of various fashion products and its assortment. Therefore, Dongdaemun market, which has more than 30,000 wholesale and retail stores in one area, is a marketplace where anyone can easily shop for a variety of fashion products.

What is more unique than anything else is that many

of the fashion products on such a large marketplace are manufactured and supplied by 15,000 small but strong sewing factories in Gangbuk, Seoul.

Each sewing factory produces a few items and a small amount of fashion products, and it becomes a huge number of merchandising for Dongdaemun market which is a big fashion production-sales complex. U.S. President Joe Biden said.

"There is nothing we can't do, if we do it together."[1]

We were very impressed with the President's speech. In particular, the people of small & medium-size sewing factories that have partnerships with Dongdaemun wholesalers will be more and more impressed.

The history of Dongdaemun market, starting a business with commerce system of manufacturing and selling fashion products in one marketplace can be traced back to the early 1960s. At the time, many merchants in the market (Initially started with Pyeonghwa market) had a clothing store on the first floor of the market, and a sewing factory plant on the second and third floors, and produced and sold in one marketplace.

As the scale of Dongdaemun market expanded in the 1970s, quite a few small sewing factories was built in the surrounding area of the market, and now the fac-

tory district is spread over the Gangbuk area of Seoul. Although these sewing factories were self-employed business with a small scale of capital and plants, they achieved remarkable management performance by doing business with small wholesale and retail shops at Dongdaemun market. In praise of this phenomenon, Koreans often use the proverb "Little pepper is spicy."[2]

We have always said that fashion products in Dongdaemun market have strong competitiveness in the global market through triple management of products, speed, and price. Perhaps no one will be able to object to this discussion. However, let's consider Warren Buffett's quote about how to invest.

"Without passion, you don't have energy, without energy, you have nothing."[3]

That's the right view. CEOs of small-scale sewing factories in Gangbuk, Seoul, have 'passion' that has been the driving force of economic growth and development that achieved 'the miracle of the Han river,' under the banner of "Let's overcome poverty and live well."

They have been working hard with this passion. The employees of the sewing factory had a desire to earn money by working diligently and later become the CEO of another new sewing factory by themselves. Sometimes,

they made life plans to become an owner of wholesale or retail stores in Dongdaemun market.

Needless to say, this enthusiasm not only inspires the will of work and increases labor productivity, but also played a role as energy in maintaining the competitiveness of supply prices by going to the market with rational management and cost-saving production.

Quite hardly, despite the catastrophe of the Covid-19 pandemic, their small-scale sewing factories are now trying to achieve great management performance as small but strong companies while continuing innovation toward smart management amid the new wave of the 4th industrial revolution.

Similar to the eloquence of the President of the United States, there is nothing they can't do, if they work hard with passion.

With its great performance, fashion biz's Dongdaemun style, which is causing an increase in demand under a large number of items-small quantity production system, rather than an oversupply under the small number of items-mass production system, is truly a way of 'Every little bit helps'.

Smart Management of Factory

"Designer brands for less every day!"[4]

It is a slogan of advertisement from the luxury discount store Ross (Dress for less). These discount stores are flourishing thanks to consumer preference for luxury fashion products.

Similar to a shopping mall like this, designer products in Dongdaemun market are sold well at lower prices. We have described one of well-selling phenomenon as the performance of triple management of Dongdaemun market merchants such as fast, good and cheap.

As well as, such marketing strategy of Dongdaemun market wholesalers be explained by 'the law of scissors.' Of course, we will explain and discuss this law in detail in the next chapter.

The bigger the scissors, the better it cuts. Likewise, the higher the quality of an item of designer products,

the lower the price of the products, the more it sells. The larger the gap between the quality and the price of the produts, the greater the sales volume.

As the law of scissors, Dongdaemun market merchants have been seeking to increase sales while widening the gap between the design value or quality of fashion products and the price level.

In the later stages of development, however, Dongdaemun market merchants are failing to achieve management performance of their strategic tools because of higher cost factors such as high wages, lack of human resources, or increased rents for shops, and so on.

In the one urgent situation, new strategic alternatives are being proposed. It seems to lie in the smart management of the sewing factory more than anything else. As widely agreed, what smart management means is a fast, intelligent, powerful strategic tool, and its management technique. A discussion of those factors is noteworthy.

First, smart management starts with 'fast' decision making and its execution. People often say "Now or never." Likewise, an item of fashion products is meaningless unless it is new. With this ICT-based smart management, therefore, Dongdaemun merchants will be

able to identify consumer preferences and produce and supply better designed products more quickly.

Second, smart management has great significance in that it often achieves great management performance through intelligent business behavior. Now, Dongdaemun merchants should practice 'new management from knowledge' instead of management gained from experience.

Third, smart management is one of the strategic tools to strengthen market competitiveness. We are proud that Dongdaemun Fashion Cluster has overcome the difficulties by having partnership with wholesalers, designers, sewing factory employees, and so on. Of course, that's not enough.

In order to improve competitiveness in a better global market, it will be necessary to pursue 'smart management through broader networking' rather than simply 'management together'.

Prior to this discussion, first, "What is networking management?" It would be nice to see a discussion of a management consultant.

"Data moves through your network like blood through veins, delivering vital information to employees who need it to do their jobs. In a business sense, the digital network is the heart and circulatory system. Without a prop-

erly functioning network, the entire business collapses."[5]

That's why transform Dongdaemun wholesalers' strategic partnership into competitive advantage. In fact, the Dongdaemun Fashion Cluster is always at risk of a market crisis because it is composed of countless small-scale merchants and designers, as well as manpower from sewing factories.

While working together, therefore, the people there should not forget that safety is important first, last, and all the time. Of course, people said that there is safety in numbers. But the word alone is not enough. Rather, such a wise response to the crisis should take priority.

"In the midst of chaos, there is also opportunity."[6]

Quoting this strategic discussion by Sun Tzu, a Chinese historical intellect, we will be able to find an alternative solution in the situation of crisis.

As a proverb in English, "Nothing ventured, nothing gained."[7]

Swan Lake and Tears

"The founder's mission was not only to make his clients, indeed all women, more beautiful, but also to make them happy, to help them dream."[8]

Dior, a global fashion company has inherited the management mission of Cristian Dior, one of fashion legends. As Toledano Speech pdf, the fundamental value that Mr. Dior aimed was the beauty in women and the best in all people.

People often view factors that influence fashion as design work, celebrities, movies or music, fashion stylists' behavior and economy of a country, and so on. Among them, music is one of the most emotional factors. As an example, the famous Tchaikovsky's music seems to have a great influence on fashion and its style.

"Tchaikovsky's first ballet, Swan Lake is a timeless love story that mixes magic, tragedy, and romance into

four acts. It features Prince Siegfried and a lovely swan princess named Odette. Under the spell of a sorcerer, Odette spends her days as a swan swimming on a lake of tears and her nights in her beautiful human form."[9]

The very genius musician Tchaikovsky composed and directed the Princess and Swan Lake beautifully.

"At night she has to stay over the surface of the lake when moon comes up. With a bright light, she transforms back into a lovely princess. When the moon sets, she transforms back into a swan again."[10]

While the swan on the lake is beautiful, however, the tears that come from the hard swimming under the water are not revealed.

I remembered the performance of the ballet Swan Lake, which I watched in St. Petersburg while traveling abroad, and the audience stood up and applauded. As I think, the beautiful appearance of the ballet dancers on the stage, behind them, there will be sweat and tears from endless practice and performances.

Of course, the swan will soon still look beautiful on the lake, but people probably won't be able to see the sweat dripping from its hard swimming under the water. Likewise, behind the beautiful postures of the dancers on stage, there seems to be sweat and tears overflowing

with constant practice and performance.

Just as there are sweat and tears behind the beautiful figure and dance in Swan Lake, Dongdaemun merchants seem to bear the opportunity cost, which is also indicated by hard work and low wages.

A business woman, Coco Chanel's quotes are also no different from the logic we are discussing now.

"There is a time for work and a time for love. That leaves no other time."[11]

As quoted earlier, Chanel's pioneering business and her life which couldn't waste any time other than work and love, are worthy of example. As it is with its management philosophy, Dongdaemun merchants should have all their eggs in one basket. That's a situational logic.

It is true that things are tough. And the market is flat. They, however, must do or die. Now that the aftershocks of Covid-19 pandemic does not stop, there is nothing else other than the spirit of age that Dongdaemun merchants should maintain.

Earlier we discussed that a Swan and her beauty were accompanied by opportunity costs such as sweat and tears. It is inevitable that Dongdaemun merchants suffer, and these high opportunity costs are also the best alter-

native, as investing.

"The solution is not far to seek."

People often think that reducing the opportunity cost is more efficient. But without any cost, there really is no performance. Or rather, the greater the opportunity cost in the world, the greater the performance. This is like a proverb by Koreans that luck comes after hard work.

As a late-development syndrome, maintaining lowwage management is no longer easy for Dongdaemun merchants. As well as, it is not easy to supply designer fashion products at low prices.

Is there any alternative? Of course, there is. Even if it is difficult, the management should be focused on not only technological innovation but also improvement of labor productivity.

"Now is time."

Labor Productivity

"Dongdaemun market is one of the world's leading business-type sites with one-stop supply chain that includes design, fabric and parts procurement, sewing and physical distribution." Professor Janice H. Hammond from Harvard Business School explained.[12]

As everyone knows, Dongdaemun market immediately sells fashion products manufactured by many sewing factories around the market. On the other hand, few people know the story of the birth of such a sewing factory.

After the Korean war, which lasted for three years from 1950, the Pyeonghwa market with such a business system was first created on this marketplace. In the Pyeonghwa market, shops were open on the first floor, and sewing factories were located on the second and third floors. When designing the market building, some

of sewing factories were also put together.

According to this unique business system, merchants in Dongdaemun market produced and sold fashion products in one place. It was a wonderful thing. Since then, the sewing factories scattered widely in north of a big river, Seoul, have grown more and more due to increased market demand for Dongdaemun fashion products.

That's a business system of Dongdaemun-style, which sells designer fashion products at low prices and continuously obtains management performance.

In the late stage of development & growth, however, many sewing factories are under pressure due to rising wages and various higher cost factors. The number of sewing factories that closed is even increasing. Of course, the Dongdaemun market has also become difficult to continue with strategic alternatives to sell designer fashion products at low prices.

Then, is there any new strategy to improve the productivity of the sewing factory and reduce its production cost?

One of the strategic alternatives is 'smart management,' which operates on fast, intelligent and powerful strategic tools and its management technique, and so forth.

"We need it yesterday."

At present, the Korean government is pursuing a new economic policy to the 4th industrial revolution based on ICT technologies such as AI and un-tact business, and Robot, and so on. Such a government's new industrial policy can be a great opportunity for factory innovation for many small sewing factories in Gangbuk, Seoul.

More than needs, fashion and its sewing industry are suitable for urban industrialization, and can lead the progress of the 4th industrial revolution toward the future than any other sector. The praise of a young gentleman who says "The pearls looked good against her tanned neck." is never exaggerated.

Sewing factories around Dongdaemun market are no longer able to maintain a low-wage, labor-intensive business system. The change is really urgent.

"Change is not a threat, it's an opportunity. Survival is not the goal, transformative success is."[13]

Seth Godin, a columnist from Entrepreneur, an American business magazine said. He's quite right. We are sure that the sewing factory on the supply-side, the answer to overcome the crisis is nothing but innovation.

All sewing factories need to focus on the employment

of young workers with ICT technology, as well as the improvement of productivity through their dreams and passions.

As the people-made Korea's economic development has shown, if the quality of work life improves, the sewing factories will also increase management performance by improving labor productivity.

In addition, the sewing factories must follow innovation in the system such as specialization, division of labor, networking as well as outsourcing, and all that jazz. They have many things to do. People are always saying this.

"A miss is as good as a mile."[14]

Accept it and if necessary, be the whole man at the work!

In fact, many small sewing factories in Gangbuk, Seoul need to pay more attention to improvement of labor productivity as a strategic task to increase business performance. As we knew well, labor productivity measures output per labor hour.

In order to increase labor productivity, many of these sewing factories must invest more capital, advance technology, and develop more active human capital, although resources are limited.

Dongdaemun Fashion Cluster needs to support physical and human resources to overcome the resource limitations of its members, and furthermore, it needs to act as a control tower. It consists in building 'together and separate' partnerships while each individual sewing factory pursues specialization and outsources each other.

Specialization and Outsourcing

In the growing trend of online commerce, we can argue that Dongdaemun merchants are rewriting a miracle story that happened over 20 years ago. Rather, it is true that the curtain of the 2nd Dongdaemun myth has already risen.

"Good begun is half done."[15]

Like this Korean proverb, the increase of online commerce is the necessary condition of the 2nd Dongdaemun myth. If so, what is the sufficient condition of the 2nd Dongdaemun myth?

As we all know, Dongdaemun merchants have been selling designer fashion products at low prices since early 2000s. Since then, the growth of Dongdaemun market and the mythical management performance was due to the hard work of human resources which has worked in many sewing factories located in the northern region

(Gangbuk) in Seoul as well as Dongdaemun merchants.

Originally, miracles or myths cannot be done by people. That is to say, only God can do it. On the other hand, the Dongdaemun myth were made by Koreans and 'dexterity' which they are proud of.

In the late stages of development and economic growth, however, the sewing factories suffer from poor plant facilities and equipment, old management system, and high wages and high costs, and so on.

In this management crisis, executives and employees of the sewing factories began to change their thoughts and actions. In particular, with the development and spread of ICT, many sewing factories have been attempted new innovating strategy such as smart management.

Such smart management of sewing factories can be discussed as one of sufficient conditions for the 2nd Dongdaemun myth.

Nowadays, global consumers generally prefer the fashion products they wanted to buy according to the following priorities: (1) design, (2) quality of products, (3) brand, and (4) price. In view of this consumer preferences, it is easy to see that price levels are not important at first glance. If an item of products has a high price level, however, the market competitiveness of

the products will be weak.

In this sense, the smart management of the sewing factory in Gangbuk, Seoul is late, but paradoxically, it can be said to be a quick step.

In addition to the management innovation of sewing factories, its structural change is also many like (1) progress in specialization, (2) division of labor and productivity improvement, (3) expanding outsourcing scope, (4) mass production of personalized fashion products, and (5) broader cooperation and alliances, and so on. [16]

Management innovation in such a sewing factory is not an easy task because structural reforms must be carried out first. First of all, there are words that are frequently used by Westerners, and it is necessary to think about the meaning of them.

"Doing everything is doing nothing." [17]

What this saying implies is that the productivity of sewing factories in Gangbuk, Seoul is low because they are doing all the sewing processes without specializing in fashion items under a small business scale.

In the future, many sewing factories must have different items or sewing processes, outsource each other, and establish mass production systems through division of labor partnerships. A separate specialization for each sew-

ing factory improves productivity through cost reduction and skill enhancement more than anything else, and a mass production system through division of labor between sewing factories can ultimately increase market competitiveness.

As we knew well, division of labor means that the main process of production is split up into many simple parts and each part is taken by different workers who are specialized in the production of that specific part. For example, in a large scales readymade garment factory, a man does cut of cloth, the second man stiches clothes with machines, the third buttons, the fourth makes folding and packing, etc.

The establishment of a mass production system through partnerships and mutual cooperation such as division of labor and outsourcing discussed by Adam Smith, the father of economics, is a sophisticated strategic task of Dongdaemun Fashion Cluster.

As SeoulClick CEO Lee Yong-woo admitted, the innovation and smart management of the sewing factories is the infrastructure for sustainable management and development of Dongdaemun Fashion Cluster.

In the future, merchants in Dongdaemun market will be able to achieve amazing trade performance through

triple management which focuses on superiority of products(good), speed(fast), and price(cheap).

<Notes>

1 nytimes.com

2 Why don't you try to taste Shin Ramyun. Just like the Korean food, there is such a proverb in Korea.

3 www.google.com

4 Marketing strategy ROSS is to give customers shopping opportunities to save money, he said. they claim. We're big—as the nation's largest off-price retail chain, we have a great deal of purchasing power. We're savvy—our buyers search the globe for the best brands and latest styles. We work directly with manufacturers to negotiate the best deals!

5 https://blog.gigamon.com/2019/03/21/what-is-network-management/

6 Johnnie L. Roberts, The Big Book of Business Quotations, Skyhorse Publishing, 2016, p.320.

7 Prime English-Korean Dictionary, 6th Ed., www.bookdonga.com., 2021.

8 dior.com/UK

9 theswanprincess.fandom.com/wiki/Odette…

10 Ibid.

11 avacarmichael.com/15 Reason-Why Coco Chanel was Successful in Business.

12 www.youngnam.com

13 www.thegrowthfaculty.com/blog/sethgodininspirationalquotes

14 Prime English-Korean Dictionary, 6th Ed., www.bookdonga.com., 2021.

15 This is a proverb that Koreans enjoy using, and there is a similar proverb in the English dictionary., Prime English-Korean Dictionary, 6th Ed. www.bookdonga.com, 2021.

16 It is a logical infrastructure condition for the smart management strategy of the sewing factory in Dongdaemun market. Further research is needed.

17 Merriam Webster was published America's most trusted dictionary.

The Law of Scissors and Wholesaling

Fabric Market and Competitive Edge

Sometime in the fall of 2021, an employee of SeoulClick, the export agent for fashion products at Dongdaemun market received an email. This is one of several emails from all over the world.

"Could you send us some new fabric samples for our new collection, please?"

The company purchases high-quality Dongdaemun fashion products that quickly adapt to trend at low prices and exports them with customer service that inspects them. For one reason or another, the company is well known to domestic & foreign fashion retailers and buyers.

Recently, the overseas trade volume of fabric and parts in addition to finished products of Dongdaemun fashion is rapidly increasing, said the company officials. It is interpreted as a response to the strong supply power of

the Dongdaemun market, which has a competitive edge in the global fashion business world, especially in 'the merchandising of novelty and diversity'.

As we all know, fabric is a very important commercial item in fashion design as well as manufacturing and sales of finished fashion products. Here's a related discussion on the Ellin blog.

"The fabric is like drawing paper, which is indispensable for the realization of a design. By analogy with farming, design is like choosing a crop and growing it well. In this way, the fabric can be described as a field that enables a good harvest."[1]

Just as seeds can grow well in fertile soil, it is argued that good fabric will lead to good design and to manufacture and sell better fashion products.

Not only that, along with the choice of fabric, which fabric stands out more depending on the pattern, etc., becomes an important decision-making in manufacturing and selling better fashion products.

As everyone can see, the boom and growth of the Dongdaemun market and the enhancement of its market competitiveness are not only achieved by selling products of designer brands at a reasonable price, but also thanks to the strong supply chain system in the market.

In particular, Dongdaemun market is stronger than ever with the smooth supply of new and diverse fabric and parts under a tight supply chain system.

Already, global fashion retailers and buyers seem to be amazed by the speed of manufacturing and trading of Dongdaemun fashion products, as well as the size of the fabric and parts market and the number of stores that enable and sustain that speed.

"There is fabric and parts market that sells new and various items in the Dongdaemun market. When I visited the fabric market, I realized that there was a great deal of small and medium-sized stores. Such a marketplace is not found in any other European country, including England. It's an amazing market."[2]

This is the discussion of Aaon Dezonie, CEO of DarkCircle Clothing, Ltd., a British clothing import company. Dongdaemun market has a history of more than 100 years along with the modernization period.

Meanwhile, the famous Pyeonghwa market, which started in the 1960s, is like an early morning in the Dongdaemun Fashion Cluster because design, manufacturing, and sales were carried out together in a space of the marketplace.

In this way, Dongdaemun market has been equipped

with a supply chain for fashion products such as whole-sale and retail markets, fabric and parts markets, and sewing factories.

Especially, as the size of the market expanded, Dongdaemun Shopping Complex became a world-sized fabric and parts market in 1970. Furthermore, as the fabric and parts market expanded, Dongdaemun market also surprisingly became the largest fashion wholesale market in the world.

At Dongdaemun Shopping Complex, anyone can see and choose from new & diverse items ranging from cotton, wool, silk, rayon, and denim, to their colors and patterns. There some pieces of cloth and vivid photos displayed at the market site are also fantastic.

In the new wave of the fashion revolution, many Dongdaemun market people are introducing new and diverse patterned items with the intention of manufacturing and trading eco-friendly fabric.

The fabric and parts of Dongdaemun Shopping Complex have maintained their competitive edge in the market through the accumulation of experience and technical know-how accumulated by fashion designers, pattern makers, and textile factory executives and technicians since 1960s.

As a point to emphasize, the commerce of fabric and parts markets has further improved its market competitiveness by stimulating and adapting to the needs and wants of fashion retailers and buyers, and the rapidly changing trends of colors, and patterns.

Above all, Dongdaemun Shopping Complex has a small quantity of various fabric and parts that are manufactured and shipped in line with changing trends thanks to the use of technological tools of the 4th industrial revolution, such as big data and 3D printing.

As mentioned earlier, SeoulClick, an export agency, is achieving global marketing performance by selecting, inspecting, and exporting fabric and parts as well as finished products.

It's just wonderful. That is because it was a marketing performance in the midst of the unprecedented global Covid-19 pandemic. Of course, even amidst the aftereffects of the pandemic, these fabric and parts market are becoming rock-like infrastructure on the way to the fashion revolution leading to the future of Dongdaemun market.

The Law of Scissors

"The customer's back is also quite beautiful."[3]

From the perspective of a fashion marketing strategy, this view can be interpreted as saying that a merchant is willing to go 10 miles to go 5 miles.

As such, it is a clever management of customer service to think that even customers who are looking for something and go out without buying are beautiful. That's because the store's employees have the belief that their customers will likely come to the store again.

However, such a management of customer service has changed radically since Walmart and many large discount stores rapidly expanded and became mainstream with the everyday low price (ELP) strategy. In fact, many large discount stores have been operating using the technique of 'self-service low-price selling' instead of excessive customer service.

Likewise, the marketing strategy of self-service type low-price sales has become the mainstream amid the continued market strength of the global SPA brand firms that has expanded rapidly since the 2000s.

In this change of circumstances, many fashion consumers today have become accustomed to obtaining consumer satisfaction by very often purchasing fast fashion products that fit the rapidly changing trends at lower prices.

In recent years, however, many fashion consumers have changed to a consumption behavior that emphasizes trend of products or its quality rather than price level. As is often quoted, many consumers always say like Gucci's slogan "Quality is remembered long after the price is forgotten."[4]

"Most fashion consumers soon forget the price level but do not easily forget the quality of the products."

This change in consumer behavior has become more and more rapid, influenced by the side effects of fast fashion, which are prevalent today, and the increase in social cost.

In fact, many fashion consumers tend to purchase quality-first products while reducing the number of shopping, even if the economic burden is overloaded

due to the high price of fashion products. As a result, the sales scale of many global SPA brand companies and the number of their stores are rapidly decreasing.

Amid the new purchasing behavior of global consumers for fashion products, many merchants in the Dongdaemun market have started to use the manufacturing and sales of fashion products that 'prioritize quality rather than price' as a new marketing strategy. The commercial behavior and their new strategic choices are quite desirable.

In any business, everyone agrees that it is important how many general customers, and also how many regular customers, are acquired. Professor Peter Drucker's lecture was right.

"The aim of marketing is to know and understand the customer so well the products or service fits him and sells itself."[5]

In the context of pursuing low-price commerce in the meantime, some Dongdaemun merchants manufactured and sold low-quality or fake branded products. For that reason, the image of domestic and foreign fashion retailers and buyers of Dongdaemun market has been considerably damaged.

Despite such damage to the market's image, many do-

mestic and foreign buyers come and go from store to store in Dongdaemun market, as if searching for pearls in mud, and have been satisfied with their commerce by purchasing high-quality, stylish fashion products that fit the trend at a lower price.

Their global fashion retailers and buyers are well aware of the consumer's desire to buy from better designer brands at lower prices. That's why they used to come to Dongdaemun market, both close and far away. Therefore, the people of Dongdaemun market must have the wisdom to see even the back of their buyers beautifully.

What we are recommending is to quickly establish a marketing strategy for commerce that satisfies domestic and foreign buyers. The answer may be found in the law of scissors mentioned previously.

This term, the law of scissors, should be logically explained again here. Scissors larger than any other can cut paper and fabric well. Likewise, the better the quality of some designer products, and the lower the price, the better it sells.

The law of scissors is that the larger the gap between the quality of any fashion products and its price, the larger the sales scale of that products.

As we often emphasize, sustainable commerce management is worth discussing with such a law. Theoretically, the first condition for such sustainable commerce management is SPQR.

The well-known term SPQR is 'the senate and the people of Rome' in English. Just as the honor and pride as a Roman citizen remained in the hearts of people even after the fall of the Roman Empire, the meaning is that the power lies with the citizen, not with a specific individual.[6]

"The people talking here are ordinary consumers in sustainable fashion management."

On the other hand, the second condition for sustainable commerce management is to trade designer brand products at low prices. It is to obey the law of scissors.

As foreigners are reminded of 'Gangnam Style', a famous song and dance of Hallyu stars, on the outer wall of the Kyobo building, which stands tall along the main road in Gangnam-daero, Seoul, there was once a signboard like this.

"The damaged leaves of the tree are pretty because they were eaten by insects. The trace of living by feeding others is as beautiful as a star."[7]

It was a picture and its contents of a public service

advertisement that praised the beauty of altruistic life. It was widely agreed upon.

There is a saying in the English dictionary meaning "Live and let live!"[8] Then, with the law of scissors and its application, fashion marketing for customer service should be continued.

Fast Bind, Fast Find

Up to the present, many wholesalers have led the sustainable growth of the Dongdaemun market. This is because Dongdaemun wholesalers' sales are estimated to account for 90% of the total market sales.

Needless to say, Dongdaemun wholesalers, which own about 30,000 stores, are small but have strong market competitiveness.

Today, in the stage of post-development, however, they are facing a serious structural crisis amid rapid changes in the market environment, despite the accumulated experience and management know-how. Furthermore, they have been affected by unexpected crises such as the Covid-19 pandemic, and in the aftermath the crisis is continued as if all things are still.

Under these circumstances, what should Dongdaemun wholesalers do? Charles Darwin, author of 'On the Origin of Species', one of the historical famous books said.

"It is not the strongest of the species that survives, nor the most intelligent, but the one most adaptable to change."[9]

He claimed that the competitive advantage is not the power, but the wisdom of survival of the fittest. Considering the market position of Dongdaemun wholesalers, this rule of survival of the fittest is worth introducing as a mission of appropriate commercial behavior.

Lately, Gary Hamel presented his writing the answer to how to adapt to change by discussing the future of management. We will also need to discuss these alternative views with Dongdaemun wholesalers facing the crisis.

In 'The Future of Management', the author argued that companies need management innovation now more than ever.

"Management has historically been seen as a collection of tasks involving planning, organizing, controlling and incentivizing. For any company, however, the future of its management becomes emerges from the sense-making

relationships of its members, rather than being determined by the choices of a few powerful individuals.'[10]

Most people believe that the role of CEO as a business leader is to choose strategic directions and then persuade others to follow them. With executives, a modern view of strategy is about exploration and experiments, a search process of trial and error.

In addition, there are many opinions that the business environment of the future will rapidly change into 'market rather than department store, global economy than national economy, omni channel than offline, platform rather than store, and meta search engine than advertising, and so on'.

In this way, it is clear that the future of business situation will change unpredictably. Depending on the future situation, Dongdaemun wholesalers as a competent CEO should use not only their leadership, but also strategic wisdom and its tools from sense-making of partners including designers, technicians of sewing factories, logistics service workers and domestic and foreign buyers.

So, we may be saying that the management is having talks with the workers. Americans are talking.

"Fast bind, fast find."

As we are discussing now, an urgent marketing strat-

egy for Dongdaemun merchants in the midst of a severe market crisis is to widen the gap as the law of scissors. The problem is how well it can adapt to the future market environment and its changes will determine the performance of the marketing strategy. American singersong writer Dolly Parton said.

"We cannot direct the wind, but we can adjust the sails."[11]

Then, there is no other answer than to adapt well to the changes of the uncertain future situation.

The Flower and its Strength

Dongdaemun merchants are praised for being good at commerce, armed with a strong entrepreneurship in a market like a battlefield. Their merchant spirit can be compared to Mugunghwa, which has the characteristics of a strong flower.

This flower, the Mugunghwa (Rose of Sharon), is the national flower of Korea, which blooms lushly from July till November. Beautiful, pure, well-bred, and tough, this flower resembles the national character of Koreans who have sustained independence and prosperity, defending against numerous foreign invasions in the long history of the nation.

Any young Korean soldier, who went on a battlefield, sang a patriotic song, vowing to his mother that he would definitely win and back home. The song by Korean artist Sim Soo-bong, 'the Mugunghwa,' was sung

as follows.

"At that time, the flowers of Mugunghwa bloomed. The flowers bloomed to leave this word. With patience, anyone wins. Those who are not afraid of death gain. And it will be a lamp tomorrow."[12]

The praise song for Mugunghwa is a perfect match for the entrepreneurship of the merchants in Dongdaemun market. The song continues.

"At that time, the flowers of Mugunghwa bloomed. The flowers bloomed to leave this word. Never give up. The flower does not bloom without tears. That's will. Please try again. They can do it. And again, the flowers of Mugunghwa bloomed."[13]

As mentioned earlier, Mugunghwa has the national character of Koreans such as (1) quickly and quickly, (2) diligence, (3) the power of unity, and so on. The merchant spirit of the people in Dongdaemun market is almost the same.

The praises of foreigners for 'Koreans' the quickly and quickly spirit' did not come from yesterday and today. The growth and development of the Korean economy from 1960s to 1970s, according to reports by foreign media such as Le Monde, France, was achieved quickly enough to be measured by cosmical standards.

Someone said it was Korean who made the Japanese think they were lazy people. Of course, we are well aware that the Japanese are still diligent.

During the 1997 IMF financial crisis, Korean people launched a campaign to collect gold to repay the country's foreign debt, contributing greatly to hasten the overcoming of the crisis. Their patriotism is also widely to be proud of.

It is thanks to the quickly and quickly spirit of Koreans that the trendy fashion products of Dongdaemun market are made possible from design to manufacturing and wholesaling or retailing in just three days.

In addition, Dongdaemun merchants, who have the diligence unique to Koreans, are doing business at the Tokkebi market, which starts at night and stays up all night until the next morning. Even after the store closes the next day, they have no time to rest to design fashion products, procure fabric and various fashion parts, and then manufacture them.

In the era of post-industrialization in any country, many people avoid 3D labor such as difficult, dirty, and dangerous work, but the people of Dongdaemun market do not avoid such work so far.

Lastly, the people of Dongdaemun market have a uni-

ty power of oxen, like the Aesop's a fable about 'Four Oxen and One Lion.' This is one of the commercial strengths discussed in detail earlier.

Whenever there is a business crisis in Dongdaemun market, the merchants always said.

"The worst was yet to come."

In fact, since the spring of 2020, the unprecedented Covid-19 pandemic has caused an extreme market crisis that has stopped even Dongdaemun merchants' commerce. After that, the number of domestic fashion consumers decreased, and after the sky and sea roads were blocked, the number of overseas fashion retailers and buyers also decreased sharply.

Fortunately, the people of Dongdaemun market are not without shopping malls closing down, but they are holding out for the survival of the fashion business through online and un-tact commerce. In doing so, they do not forget the words that our ancestors sang in the Korean history of war and refuge.

"We would die than surrender."

The people of Dongdaemun market think that closing a business is like a slave, and just as they have overcome many difficulties since opening, they are pursuing a new marketing strategy in the hope that a bright sun

will rise in the eastern sky tomorrow.

We have quite a few people like Dongdaemun merchants. Among the representative platform companies in Korea such as Naver and Kakao, Naver CSO Lee Hae-jin talked about the difficult journey of global management.

"Success in the IT industry does not come from the inspiration of a genius. I thought it would happen when everyone fails and fails and fails and has nowhere else to go."[14]

Such a difficult journey of Naver also seems to explain the path of Dongdaemun merchants who are conducting sustainable management, such as the ecology of the flowers of Mugunghwa blooming in harsh rain and wind.

Victory before the War

In 1592, Japanese army suddenly invaded and occupied Joseon dynasty, a peaceful land of ancient Korea. For the next seven years, a terrible war continued, and during that war, many people were killed and their property lost in the land of Joseon.

Shortly before the end of the war, the strong Japanese navy led over 300 warships the coastal waters of the southwestern part of the Korean peninsula, and attacked the Joseon navy with 12 old warships and some of defeated soldiers tired of the long war.[15]

Unfortunately, Admiral Yi Sun-sin, who was being temporarily punished for political party fights during the long war, had to hurry to participate the battlefield of crisis by leading the so weak Joseon navy as a classless soldier.

Just in September 1597, Admiral Yi Sun-sin resisted

by encountering a mighty Japanese warship on the narrow waterway between the land Haenam and the island Jindo in south Jeolla-do with 13 more battleships. The narrow sea road on the battlefield there was about 1.5km wide, while the narrowest road was about 500m. In such a place, the tide was so fast that it seemed like a strong cry.

As soon as the Japanese navy first attacked violently, the Yi Sun-sin army retreated and reached a narrow sea path. At that moment, the waterway suddenly changed from high tide to low tide, and the Japanese warship began to lose its balance along with the whirlpools and noise of the fierce low tide. Just in time, the Joseon navy turned its bow and shot cannons and arrows at the Japanese army.

Admiral Yi Sun-sin was well aware that the sea water always changes from high tide to low tide and vice versa every six hours. Also, even though the Joseon navy is weak, he made a good strategy to achieve victory by fighting the mighty Japanese navy.

During the 7-year war fought against the Japanese invasion, Admiral Yi Sun-sin fought 23 battles and won 100% of those battles. His military strategy was so outstanding that no case could be found in world history.

The strategy was to 'win first and then fight later' paradoxically.

Whenever Admiral Yi Sun-sin went to battle, he made a rational strategy and thoroughly prepared for the various situation and its conditions of the time and space. We are so proud of him.

Like most Seonbi who were virtuous scholars in the Joseon dynasty, Admiral Yi Sun-sin had a tremendous amount of reading on classical books at home and abroad, and he may have understood Sun Tzu's quotes as follows.

"Victorious warriors win first and then go to war, while defeated warriors go to war first and then seek to win."[16]

Although his troops were weak, he thoroughly prepared for the victory and then went on the battlefield. In this regard, how do Dongdaemun merchants conduct commerce?

In the late period of economic growth, the aging of the workforce became common in other sectors such as rural areas and small self-employed stores. In contrast, the merchants in Dongdaemun market have become younger and smarter.

Fortunately, Korea has a high ratio of college gradu-

ates to the total population, and competition for the department of management at each university is high. The fact that most of the Dongdaemun merchants are young is acceptable as most of them can conduct more rational commerce using their management know-how and information technology as a weapon.

People always talk about commerce in the context of war or sports. Dongdaemun merchants also knew that commerce management is a means to climb the ladder of success, and they thought it is especially important to find out what not to be done for management performance.

Nevertheless, it is quite difficult to predict future situation in a market that is facing a management crisis amid competition. Any American computer scientist Alan Kay said.

"The best way to predict the future is to invent it."[17]

As usual, Dongdaemun market is open every night from 8:30 to the next morning. Dongdaemun merchants are accumulating know-how in commerce through trial and error by seeing each other, feeling, and hearing in the heat of the night market. Using the strategic wisdom of Admiral Yi Sun-sin, who saved the country 400 years ago, as a mirror, they conduct better commerce

every day and further advance its technique.

In particular, Dongdaemun market is moving into the future by pursuing online and un-tact commerce to float a boat on the new wave of the 4th industrial revolution. Of course, better fashion marketing toward the future and the strategic tool are important, but how well the strategic tool is used is also very important. Morris Chang, CEO of Taiwan semiconductor company TSCM, pointed this out well in his quote.[18]

"Without strategy, execution is aimless. Without execution, strategy is useless."

<Notes>

1 www.money-news.co.kr

2 www.seoulclick.co.kr

3 dongdaemun-style.blogspot.com

4 www.pinterest.co.kr/pin/quality-is-remembered-long-after-the-price-is-

5 www.google.com/searchpeter-drucker

6 Mary Beard, SPQR: A History of Ancient Rome, paperback, September 6, 2016.

7 dongdaemun-style.blogspot.com

8 Prime English-Korean Dictionary, www.bookdonga.com, 2021.

9 www.google.com/charles-darwin

10 www.amazon.com/future-management/articlewhy-adaptability

11 google.com/search/q?

12 gasazip.com210770

13 Ibid.

14 Lee Hae-jin, My company and its retrospective story, blog.naver.co.kr

15 Korean film, The Admiral: Roaring Currents (Myeongryang)

16 Khoo Kheng-hee, Sun Tzu & Management, Pelanduk Publications, 1992.

17 azquotes.com/quotesstrategic-management.html

18 google.com/search/q?

Part
7

Competition and Market Power

Pure Competitive Market

The merchants in Dongdaemun market are doing sustainable management by selling fashion products at lower prices. Why such a management performance has been consistently achieved is because Dongdaemun market itself has fundamentally a competitive market structure.

Adam Smith, the theoretical godfather of capitalism, said earlier that price acted as an invisible hand in free competitive markets. Prior to Adam Smith, the 14th Century Syrian academic, Ibn Taymiyyah was an ancient scholar who first discussed this theory.

"If a desire for goods increases while its availability decreases, its price rises. One the other hand, availability of the goods increases and the desire for it decreases, the price comes down."[1]

Dongdaemun market is a huge shopping mall with 30,000 small wholesale and retail stores. Above all, it is

a competitive strength of the market that 100,000 designers inside and outside the market are doing more creative work, and it is also advantageous to have 15,000 small sewing factories around the market. In addition, there are many service-type enterprises with various infrastructures such as fabric and fashion part markets, logistics, hotels and restaurants, and so on.

In this Dongdaemun Fashion Cluster, all merchants have managed their commercial business well, taking advantage of a completely free competitive market. Obviously, Dongdaemun market has became famous as a marketplace where better fashion products are sold to domestic and foreign buyers and retailers at low prices under the invisible hand's action of the price.

Since the 1990s, however, large discount stores that sell daily at low prices (ELP strategy) such as Walmart and e-Mart appeared in large numbers, and the Dongdaemun market's unrivaled competitiveness has weakened.

In late developing countries, the supply of low-cost fashion products increased with a production system similar to the Dongdaemun market, as well as, the growth of global fast fashion companies such as the SPA brand were also caused to the above market crisis.

Moreover, with the Covid-19 pandemic, all merchants in Dongdaemun market were in a situation where even their survival is difficult due to the increasingly poor price competitiveness.

In the aftermath of this and that, the huge number of stores in Dongdaemun market that are now closed as if all is still.

Fortunately, many Dongdaemun merchants, such as a 'Phoenix', are opening their stores in hopes of the future. At this moment, it seems that we need to do this monologue.

"Better late than never."[2]

In fact, it is not easy to raise the price competitiveness of Dongdaemun fashion, which has been weakened in the late development period or the situation of the Korean economy that has entered an advanced economy. As in the late 1990s, it is difficult to expect the market boom at the time when domestic and foreign retailers and buyers visited Dongdaemun market day and night.

As such, everything is not easy, but in that marketplace, all efforts for the survival of the company must be continued. Even if it's late, it is better than giving up. A fashion legend, Ann Demeulemeester said.

"For me, black is not dark, it is poetic. ..."[3]

Such a sentimental quote impressed us. People in Dongdaemun market are also trying to overcome various shocking difficulties, such as online and virtual commerce and unprecedented social distancing. That's the most they can do.

Pursuing smart management amid the wave of the 4th industrial revolution that is taking place ahead of other countries, the people of Dongdaemun market will open a new path well with cost-saving production and superior price competitiveness.

"After a long winter, spring will come soon."

Competitiveness

Among the many global shopping markets, Dongdaemun market is a unique mall where a lot of small & medium-sized wholesalers maintain sustainable management in a state of perfect competition. At first glance, we cannot believe that the small & medium-sized wholesalers will be able to survive in such a perfectly competitive market.

In fact, just as to live is to fight, trading in the market is also fighting. In other words, commerce itself is an economic behavior that fights like a war. Right or not, it is a fact.

For that reason, everyone may think that a big company with economies of scale, such as monopoly or oligopoly, has great market power in the situation. However, that's not true. Or rather, in a perfectly competitive market, small & medium-sized wholesalers can have higher market competitiveness in the long run and sustained

business performance.

In such a marketplace, there is the golden rule of Adam Smith's laissez-faire economy, and it is also the land of dreams for the happiness and peace of all. Many economists explained this in their books and university lectures.

"Allocation of all resources generated under perfect competition is generated by the pursuit of individual self-interest and one which is insensitive to the actions of any single agent."[4]

"Self-interest is formalized as maximization of profits by producers and maximization of utility by consumers, both sets of actions being taken at a price system which cannot be manipulated by any single agent, producer or consumer."[5]

Dongdaemun market is quite crowded with domestic and foreign buyers who visit many wholesaling stores every night. In such a crowded market situation, it seems that bees and butterflies playing among the flowers in a bright sunny day. Analogically, innumerable wholesale shops in the market are flowers, whereas bees and butterflies are like domestic and foreign buyers looking for a variety of fashion products in the market.

Just as flowers grow and bloom in spring and summ-

er, 30,000 wholesalers are freely conducting commerce without barriers to entry in Dongdaemun market, where there is overheated competition.

These conditions of a perfectly competitive market are almost the same on the supply side.

There are 100,000 designers in Dongdaemun market, who are either wholesale store owners, employees of the store, or freelancers. So many of those Dongdaemun designers compete with each other for more salary or revenue through their better fashion designing work.

On the other hand, more than 15,000 sewing factories in Gangbuk, Seoul are also continuing to supply better quality fashion products at a lower price through improved technology and labor productivity and low-cost management in the competitive Dongdaemun market.

In addition, as another supply partner, numerous non-store producers of fashion products are supplying trendy fashion products in the competitive Dongdaemun market. And, lots of street vendors around shopping malls are also directly wholesaling. There are no high and rough barriers to free market entry in the marketplace.

As such, Dongdaemun market is completely competitive in all directions, including supply or demand side, and the marketplace.

"Monopoly and oligopoly are poison, but competition is medicine."[6]

Recently, many global fast fashion companies have faced a severe business crisis, regardless of the Covid-19 pandemic. The management crisis of these companies is, above all, in maintaining low-wage management for competitiveness with low pricing as well as lazy management as a side effect of market oligopoly.

Unlike them, Dongdaemun merchants and their partners are doing business in the midst of competition, just like soldiers out on the battlefield. They may be saying, implicitly, "To be, or not to be, and that's the problem."

In a perfectly competitive market, they are gaining a competitive advantage and growing their strength. They are looking for better marketing strategy alternatives to maintain the advantage of commerce management in a competitive market.

Such perfectly competitive markets and systems are like good medicine. That's because market competitiveness of many Dongdaemun wholesalers is a valuable reward that comes from overcoming tough competition in the market.

Free Market Entry

The unprecedented economic crisis at home and abroad is as if everything in the world has stopped. Without exception, Dongdaemun Fashion Cluster is also facing a big crisis, as if everything has stopped.

As every cloud has a silver lining, hopefully, the end of the crisis will come to us someday. The question will depend on how we meet the market situation at that time. This is because Dongdaemun market has had more structural problems in the market than factors appearing outside the market.

In the meantime, Dongdaemun market has grown by improving the productivity of human resources and its development will rather than capital or size of market and other physical resources.

However, the structural problem of today's Dongdaemun market is paradoxically that there is a shortage of productive manpower as well as jobs.

With a rapidly ageing population, low birth rates and young people who are increasingly shunning marriage, Korean economy is causing structural problems in the population and human resources.

In particular, the increase in the unemployment size of the elderly who were heroic industrial forces in the age of development & economic growth and the deterioration of their quality of life are big problems. An American financier, Bernard Baruch said.

"Age is only a number, a cipher for the records. A man can't retire his experience. He must use it. Experience achieves more with less energy and time."[7]

That's right. Fortunately, Dongdaemun market has many jobs and opportunities for success along with free market entry. There are many job opportunities for older people.

Dongdaemun market people also needs to find and recruit human resources who were industrial heroes in the era of development, and find a way to overcome the crisis using their experience as a weapon.

Clearly, despite the management crisis, Dongdaemun

market will recover to a V-shaped growth curve with the reinforcement of excellent human resources and management innovation. In the growth curve, start-up and job seekers with an experienced elderly population as well as a young workforce with ICT technology will be able to get new and good works easily. Furthermore, they will enjoy a better quality of working life.

Many of us were pessimistic, saying, "There is no business to invest in, no jobs." But they are not right. They should no longer be disappointed that it is a tragic situation now.

Like SeoulClick CEO Lee's management philosophy of 'doing his best every day,' anyone with a big dream should start preparing to go to the Dongdaemun market there. The marketplace is definitely a land of opportunity.

"Now, not tomorrow!"

Fashion biz often gets forgotten about when discussing the great technological advances of today, but it is a business sector that can benefit a lot from this wave of new technologies.

Standing at the entrance of the 4th industrial revolution, we have countless strategic challenges and opportunities in the fashion business.

"For fashion biz, the 4th industrial revolution brings

us new fabric and new manufacturing technique powered by a wave of new innovations across the physical, biological and digital worlds, such as 3D printing, artificial intelligence and bio materials."[8]

Furthermore, since Dongdaemun market is a land of free market entry and opportunity, it is necessary to provide employment and profitable start-up opportunities to high-quality human resources from around the world. Much of all, it is a new marketing strategy for the expansion of Dongdaemun wholesalers' global management.

In the future, Dongdaemun wholesalers will be able to maximize their commercial performance in such a state of free market entry and perfect competition.

Faster and Faster

"We know that H&M, one of the global SPA brands has been in a crisis due to the Amazon effect. However, the crisis of this companies is the result of lack of sustainable management."[9]

The media criticism is spreading to all other global SPA companies like Zara, UNIQLO, etc. As well as, the criticism of these global SPA brands is not over.

As a more detailed review, the global SPA brands are facing another crisis.

SPA brand products such as Zara, H&M, UNIQLO have gained popularity from consumer in the global market. But their products are not so 'fast'. Rather, it is an item of products with lower quality or slower speed as a by-product of old mass production era.

Now it is a new era of producing small quantities of various products to suit consumer preferences. Today's

consumers do not like products that are manufactured using automation machines. They prefer handmade fashion products rather than machine-made ones.

We remember such a proverb like "There is no accounting for tastes."

Tadashi Yanai, CEO of UNIQLO, said "Our company is not a fashion company, it's a technology company." As quoted earlier, his public confession is right.

On the other hand, Dongdaemun fashion products will be a winner in the competition against global SPA brands, by being 'faster and faster'.

Merchants in Dongdaemun market are proud to make and sell 'different' designer products or items with 'newness and its diversity' very quickly in 3 days at more than 30,000 stores.

In general, any item of products has a human life-cycle like birth, growth, maturation, and aging. In particular, in the case of fashion products, the business has a distinctive life-cycle, and its influence on commerce is remarkable.

The life-cycle of an item of fashion products is the process by which certain designs, fabric, parts, colors, etc. gain some popularity and gradually lose their popularity. It consists of five stages: the introduction,

rise, peak, decline, and disappearance stage. Some trends stay in the peak stage for much longer than others.

What is interesting about the fashion life-cycle is that every trend has fallen at one point or another. That's why it's worth having this discussion.

"Among them, the second stage of life-cycle is the rise stage, in which trends pick up in popularity. Most of the time, trends grow an audience through working with influencers and other companies to further advertise and spread the word."[10]

In this stage of growth and maturity, Dongdaemun merchants must continue smart production and shipment through rapid decision-making and products innovation to extend the duration. In other words, it is necessary to continue the fast and fast strategic alternative as it is in the Dongdaemun-style of commerce. An American software engineer Kent Beck said.

"Make it work, make it right, make it fast."[11]

Of course, it is difficult to frequently change fashion items in the midst of rapid trend changes. In other words, it costs a lot to quickly manufacture and sell high-quality fashion products. The problem is that in Dongdaemun market, high-cost designer products cannot be sold at low prices, and furthermore, the market com-

petitiveness is inevitably weakened.

In Dongdaemun market, maintaining low prices is a key that must be equipped. Nevertheless, there are strategic alternatives. That is the price discrimination policy.

This is a strategy that can be used well because the price elasticity of consumer demand for fashion products differs depending on the country, region, and income class in the global market. For example, the price elasticity of demand for fashion products in urban and high-income areas is greater than in rural and low-income areas.

Namely, high-income consumers prefer high-quality designer products even if the price is somewhat high. On the other hand, low-income consumers tend to have less demand for expensive products, even if they are designer products.

Therefore, the price discrimination policy is a marketing strategy for Dongdaemun market, like a magical medicine.

SeoulClick CEO Lee Yong-woo said, "Our company is truly selling fashion products to overseas markets." This is because foreign buyers are trying to buy 'fast' fashion products that meet the needs of consumers while still being low prices.

This strategic approach seems to be based on the

CEO Lee's management philosophy as follows.

"Merchants in Dongdaemun market should explore the way to 'export' for survival. Since SeoulClick is a company to provide services to business partner, we are doing our best to foreign buyers with 'sincerity.' Not only buyers, but also executives, dealers and other human relationships. If we trade with 'sincerity,' better commerce performance will follows."[12]

Productivity and Market Power

There is news that is still widely remembered. It is that Korean actress Youn Yuh-jung, who acted in her film Minari, received her Best Supporting Actress award at the 2021 Oscar Film Festival.

At that time, she received endless applause and praise by giving a wonderful acceptance speech to celebrities in the film industry attending the Oscar ceremony and domestic and foreign movie fans watching TV broadcasts. What's going on there?

She said that she wasn't the queen of glamorous silver screens, and today's honor is a reward for her hard work to earn a living. She also said to his family, "It's because Mommy worked so hard," and impressed many people at home and abroad.

"Youn is charming not only overseas media, but also film fans who watched the awards ceremony. Major

news outlets and online communities in the U.S. have assessed her speech to be the best award speech."[13]

Followed, Frances McDormand who won the Oscars actress in a leading role, quoted a line from the Shakespeare play Macbeth in her acceptance speech.[14]

Like Macduff fight Macbeth, she said. "I have no words. My voice is in my sword." She then continued in her own words.

"We know the sword is our work, and I like work. Thank you for knowing that, and thanks for this."[15]

The Korean economy has achieved rapid growth since the 1960s, escaped from a developing country, and became the first country in the world's history to enter a developed country through a middle-income country in 2021. This is an official announcement made by UNCTAD.

Among the factors of economic growth, education and training of technical manpower became a great driving force. A foreign economist praised Korea's rapid economic growth since the 1960s as a human-made miracle, and many have accepted it.

The sustainable growth of Dongdaemun market and the sewing factory around there was also thanks to many technocrats and their descendants who have accumulated experience and technical know-how in the Korean in-

dustrialization process led by the textile industry.

The management performance of Dongdaemun market, which was praised as Dongdaemun myth, may also be a valuable reward for the 'hard work' of wholesalers and designers, fabric and parts manufacturing and distribution workers, and numerous sewing factory employees and technicians, all of them.

In particular, many employees of sewing factories scattered in the Gangbuk area of Seoul have endured sacrifices such as hard work and low wages to supply good fashion products at low prices to Dongdaemun wholesalers. It may have been inevitable for a small sewing company to survive.

Nowadays, amid more intense global price competition, however, it has become difficult for many employees of those sewing factories to endure the sacrifices such as hard work and low wages. If so, does their small but strong sewing factory have no new strategy for corporate survival?

"When talking about a successful person, hard work is the first quality that reflects the most. To be successful, one has to cover extra miles and start earlier than others."[16]

Under this premise, one column argued that those

who aspire success and are truly determined will be in working effectively. In other words, it is explained that changing hard work into smart work is an alternative. The column emphasized that "first of all, they have to change streo-types."

Then, instead of putting a lot of effort and time doing these things done, they should have to rush to plan and invest smart ideas for the task. Of course, smart work has a lot to check.

Those checklists are, for example, (1) time management, (2) knowing what exactly is needed, (3) understanding the system perfectly, (4) making best of the right opportunity, (5) investment time in team planning, and so on.[17]

As we always argued, the global competitiveness of the Dongdaemun market lies in the sale of good quality fashion products at low prices. As such, in a situation where securing a price competitive advantage of fashion products is important, it depends on how smart the technocrats employed by many sewing factories work.

"A business that makes nothing but is a poor business."[18]

Henry Ford's such a famous quote is acceptable as a compliment for the technocrats who have kept their jobs

at the sewing factories around Dongdaemun market for many years, despite sacrifices such as hard work and low wages.

As discussed earlier, they were great industrial heroes who achieved the growth and development of the Korean economy. They are still a human resource with strength.

As they transform into smart work and increase productivity, the competitiveness of Dongdaemun market will become even stronger.

<Notes>

1 Daniel Smith, Big Ideas, 150 Concepts and Breakthroughs that Transformed History, Michael O'Mara Ltd., 2017, p.218.

2 Prime English-Korean Dictionary, www.bookdonga.com, 2021.

3 The Lives of 50 Fashion Legends, Fashionary, 2018, p.100.

4 John Eatwell and Others, The New Palgrave A Dictionary of Economics, vol. 3, The Macmillan Press, Ltd., 1987, p.831.

5 Ibid., pp.823-5.

6 www.seoulclick.com

7 www.britannica.com/biography/bernard-brauch

8 www.fashionandbook.co.kr/the-fourth-industrial-revolution

9 Reviews of many media's SPA brands are as follows.

10 dongdaemun-style.blogspot

11 He is an American software engineer.

12 www.seoulclick.com

13 www.donga.com/enarticle/all2021428, "Youn was a godsend," report NYT

14 variety.com/2021filmnews/Oscars-best-actress-frances-mcdomand.

15 We knew that Macbeth is a tragedy by William Shakespeare.

16 empxtrack.com/blog/performance-management-tools-turn-hard-workintosmart-work

17 Ibid.

18 www.googl.com/search/q?

Part
8

Quality Massage

Products, Products, and Products

The 4Ps of marketing is one of strategies that has been widely adopted in the business world since the 1960s. According to 4Ps theory for marketing, the strategic tools deal with four important factors like products, price, place, and promotion.

Since then, some companies have been pursuing the 5Ps marketing mix including 'people' as a new strategic alternative. In addition, the spread of discussions such as the 7Ps marketing mix has continued as well.

And, in the end, new strategies such as the 20Ps marketing mix have been proposed.[1] The marketing mix of 20Ps includes not only 4Ps, but also new strategic elements such as people, planning, persuasion, publicity. As to the rest, the 20Ps marketing mix includes important elements such as passion, push-pull, packaging, profit, power, partnership, productivity, positioning, per-

ception, positivism, professionalism, personality as well.

Many of these strategic tools will help any fashion company achieve its marketing performance.

On this generalized marketing theory and its practice, we would like to discuss a strategic alternative such as the marketing mix of 3Ps. Although opinions vary on the importance of various elements of marketing strategy, we intend to prioritize that the first is products, the second is products, and the third is products. At least, the fashion marketing we are discussing, the Dongdaemun-style, and its strategic task are as follows.

"First of all is make or break 3Ps marketing mix."

For any company, the quality management of products is an important strategic tool in the marketing mix. Be it one of the fashion products, the marketing mix majorly depends on the products for other aspects like promotion, place and price, and so on.

In fashion marketing, one of the products is not only producing a commodity, but also the overall benefits that the products can provide. The quality management of fashion products is also a strategy to manage design, brand, symbol, guarantee, and image, etc.

"Style is the only thing you can't buy. It's not in a shopping bag, a label, or a price tag. It's something re-

flected from our soul to the outside world. That's an emotion."[2]

As Israeli fashion designer, Alber Elbaz said, more than anything else, the emotional value of the fashion products will have a huge impact on the strategic performance of the marketing mix.

Needless to say, the emotional value of a fashion item is based on the economic value of the products. That is why quality control of the products is important. In fashion marketing, quality control must be thoroughly executed from the initial stage of raw material sourcing to the sewing stage of the final products.

As we have often mentioned, SeoulClick is a trading company that purchase by proxy for Dongdaemun fashion products, fabric and parts for domestic and foreign buyers. The small but strong company is investing a lot of human and physical resources to inspect Dongdaemun fashion products and control of its quality, rather than such simple trade business.

That is why the export of fashion products and their marketing performance must have high reliability in the quality of the products, as well as the products, speed and price, etc.

The inspection system for which the service is supplied by the company, is checked to ensure that there is no color variation, weaving defect, fabric defect, printing defect, holes, poor stitching, bad smell, dying defect and stains, etc. in the Dongdaemun fashion products.

"Price is what you pay. Value is what you get."[3]

We understand one of these Warren Buffett's top ten rules for success. As the saying goes, they seem to be thinking about how important inspection and quality control of fashion products are.

The following advice from Erin Huffstetler also tells them how important quality management is in fashion marketing.

"Quality clothes are an investment. If you take care of them, they'll hold up for years to come."[4]

Recently, Mrs. Chung Jeong-sook, editor of a newspaper K-fashion, said in her column, "Dongdaemun Fashion Cluster, there must be developed into an ant army." said.[5] That's make two of us.

A strategic alternative is to select 100 products of excellent design every week and hold a cyber fashion show, as well as order large quantities of the items and jointly advertise and promote them.

Quality Message

There is a keyword used in management and marketing strategies called QM (Quality Message).[6] QM means that quality of any commodity and the consistency is an advertisement, rather it is a message to buyers and consumers.

Quality has the same effect as advertising. This is because when an item of products is made well, the market evaluation is good and the demand for the products will also increase. Furthermore, there is no need to pay excessive advertising costs.

Many domestic and foreign consumers often think that electronic products manufactured by excellent companies such as Samsung and LG are always good quality. In fact, their electronic products are of good quality and are loved by many consumers because of its quality.

Those two companies continued to gain the image of the company that always makes good quality products, and as a matter of fact, the management performance of advertising and promotion is great.

Amorepacific is loved by a huge size of Chinese consumers for the quality and its value of the various cosmetics produced and supplied by the company. This marketing strategy based on quality rather than price was finally rewarded.

Wholesalers in Dongdaemun market also send messages to domestic and foreign buyers that the fashion products in the market are of good quality, prior to Ads & promotion. Apart from discussing the truth or not, Dongdaemun style, the market power of its products is strong.

Of course, there are many factors of its strength, but first of all is the newness of the products and its diversity.

As we all know, smarter domestic and foreign consumers do not like fashion products that are manufactured using automation machines. They prefer personalized fashion products over mass produced ones.

Surprisingly, global SPA companies that have grown steadily are facing a serious management crisis under the

turn of the tide. The Amazon effect of the online business is also having an impact, but the negative image on products of the SPA brand and its quality is also a big cause.

Unlike the global SPA brand companies, however, Dongdaemun market is continuing its speed management. It may be leading the global fashion market by 'faster and faster'.

The Dongdaemun fashion products are not mass-produced by machines, but as customized products. Numerous sewing factories around Dongdaemun market have been producing faster and excellent fashion products despite difficult management conditions. There was a praise on Dongdaemun fashion products from a business man, who is the chairman of a large Chinese company.

"With the four strengths speed, trend, good quality and low price, Dongdaemun market system is not seen anywhere else. The market system is superior to global SPA brand Zara."[7]

Despite such praise for Dongdaemun fashion products, the spread effect in the global market is insufficient. So, many Dongdaemun merchants are attempting advertisements to widely inform, persuade, and remind the prod-

ucts they have shipped.

But advertising is costly. Furthermore, advertising in the global market is immeasurably costly. The side effect of raising the price is inevitable even with minimal advertising costs. As we are widely aware, the book written by Al Ries couple said.

"Now the era of advertising is over and the era of PR has come."[8]

Didn't we say quality is advertising early? In fact, it is correct to say that it is an advertising effect of quality. Rather, PR is a promotional strategy alternative that can be used instead of advertising.

In other words, better designer products and improving their quality will be sustainable commerce with PR strategies such as low-cost advertising.[9]

PR(public relation) is a strategic communication process that builds mutually beneficial relationship between organization and their products. Commercial performance can be expected when merchants communicate continuously to increase supply-side partner satisfaction as well as customer satisfaction.

In the recent, ahead of the post-Corona era, import demand for various types of 'Korean made products' in the global market have increased rapidly. In other

words, the popularity of buyers and consumers from all over the world about K-products is further improved.

"Strike the iron while it is hot."[10]

We should all understand the true meaning of this proverb. Dongdaemun market people must maintain a sustainable management that produces and sells good designer products at low prices.

Buyer Satisfaction Commerce

Theodore Levitt, former professor at Harvard Business School, informed Dongdaemun market wholesalers what should be done first.

"The true purpose of business is to create and keep lot of customers, not to make money."[11]

He explained the logic that emphasized the importance of partnerships with customers in doing commerce. Someone said that if it is not almost 100% customer satisfaction, many customers will leave on their own.

As with this discussion, Dondaemun wholesalers should understand the desires of fashion retailers at home country and abroad and help them make more money. This is because as it is impossible to continue doing commerce with them without the help of many buyers, the partner of transaction.

"Customers today want the very most and very best

for the very least amount of money payment, and on the best terms. Only the individuals and companies that provide absolutely excellent products and services at reasonable prices will survive."[12]

Dongdaemun wholesalers are trying to provide commercial services so that customers, such as domestic and foreign retailers and buyers, can make a lot of money by purchasing and retailing better fashion designer products at a lower price.

Of course, domestic and foreign fashion retailers and buyers should also understand the wants and needs of consumers as a customer.

Now, we need to rethink Walmart's management philosophy. It would be say that the sustainable management of Walmart was based on an American industrial hero Sam Walton's entrepreneurship. Namely,

"Walmart helps people save money and live better. Walmart International delivers on this promise by bringing value and convenience to millions of customers."[13]

To solve this discussion, it is the logic that Dondaemun wholesalers with domestic and foreign fashion retailers and buyers should satisfy the needs of consumers and make them happier. There is an American proverb.

"Two heads are better than one."[14]

Similar to this proverb, Koreans said that even a piece of light paper is lighter when two people lift it together.

The business of retailers, trading partners of Dondaemun wholesalers, is fundamentally in merchandising small quantities of fashion products. And, since fashion consumers have different preferences, retailers must satisfy their wants and needs through merchandising with a variety of products. Moreover, retailers have to merchandising and assorting of fashion products according to consumer preferences that change rapidly with trends.

Fortunately, Dondaemun wholesalers will be able to sell very best products at a lower price thanks to the supply-side partnership, further inducing consumption demand from global fashion consumers.

In addition, Dondaemun wholesalers will continue to achieve even great management performance if they continue to understand and help retailers and buyers as demand side.

People often understand the meaning of TEAM as "Together everyone achieves more." This is widely acceptable. Not only that, but this proverb on the other side also

corrects.

"Company in distress makes distress less."[15]

In this book, we have attached a guide note, titled "Fashion retailing, where and how to purchase", thinking that buyer satisfaction commerce is the way to sustainable management.

It provides guidance on Dongdaemun market, which sells designer fashion products that suit the trend at low prices, and how to purchase there, for buyer-side partners who do fashion retailing all over the world. Many fashion retailers will benefit greatly from that guidance. We are sure.

As it has been in the past, Dongdaemun market will continue its sustainable management by selling very best fashion products at an appropriate price through strong partnerships with them under the banner of 'satisfying buyers first'.

Nothing but Novelty

"We don't want our clothes to exploit people or destroy our planet. Buying less, choose well."[16]

This is a social criticism of fast fashion that global SPA brand companies such as Zara, H&M, UNIQLO, and Forever 21 and so on, manufacture poorly and sell at low prices.

In the midst of such criticism, I visited apM Place in Dongdaemun market again. And I was just as impressed as when I first went there a few years ago.

"Wow, this kind of wholesale market like a department store is in the Dongdaemun Fashion Cluster!"

As apM Place visitors, they will feel like watching fashion shows at another premium shopping mall giving an inspiration of going in and out of ultra-modern building ddp. Foreign tourists, perhaps many retailers or buyers will be quite surprised to find a marketplace that

perfectly suits their purchasing wants and needs.

"I love the interior layout as well as the collections. It's definitely a boutique with really good designer items. The place is actually full of quality designer items. Above all, I was surprised by the diversity of MD."[17]

Even though the Dongdaemun myth happened a long time ago, many domestic and foreign consumers perceive Dongdaemun fashion products as not so good. They have been thinking that the price of the products is cheap and the quality is low as well.

On the other hand, the quality of the commodities sold in apM Place is not much different from the department store, but its wholesale price is cheaper than the department store. Also, it is very convenient to shop because all the aisles are wide and each shop has large space.

Unlike other Dongdaemun wholesale markets, known as one of phantom (Tokkebi) market, apM Place opens 24 hours a day (from night to daytime). In addition, the wholesale market provides the best customer service so that fashion retailers and buyers at home and abroad can 'buying and choose well' designer products at a reasonable price.

As such, while praising apM Place as a splendid show window, we expect that the wholesale management of the show window and its promotion strategy will enable the development and expansion of a wider global market.

Okay, what is the situation in the global market, such as preferences for fashion products and their demand and trends?

The Cotton Incorporated Lifestyle Monitor is the result of an empirical study. That is, nearly three-fifths of consumers believe that high-priced clothing is of better quality than low-priced clothing.[18]

On the other hand, about 73% of consumers who believe that style is not the only motivation to purchase think that low-priced clothing is as good as high-priced clothing, and the remaining one-third think that high-priced clothing has good style.

CEO Katie Smith pointed out that there is very little difference in sell-out speed between items at Zara and Gucci in spite of the very different price points.

"Zara's is $46 and Gucci's is $1,341," Smith said. "When I looked at how consumer behavior has changed over the past three years, it was surprisingly found that it has sped up dramatically. Luxury and fast fashion consumers aren't behaving that differently."[19]

In this context, what we should pay attention to is that Amazon and other online stores have stolen a lot of business. "Companies who depend on either a low cost or a high-value competitive advantage have fallen behind. Instead, they must provide both. Those companies that don't get it right could lose their customers and never get them back," The Balance financial website reported.[20]

In view of these consumer behaviors and preferences, apM Place is a pilot shopping mall of the Dongdaemun Fashion Cluster. Many global fashion consumers are motivated to purchase according to their preferred style, and even if the purchase price is a burden, they do it with the belief that the quality should be good. However, it is true that they do not like to spend too much burden like highpriced luxury fashion products.

What is quite interesting is that many overseas fashion retailers and global buyers have a high preference for apM Place's fashion products, and in fact, they are increasing their transaction volume with apM Place amid an explosive increase of consumer demand for Dongdaemun's fashion products.

While praising apM Place as a splendid show window, we suddenly remembered the quote of the founder of

Hershey's. Legendary CEO Milton S. Hershey said.

"Don't find customers for your products. Find products for your customers."[21]

Hershey's, which conducts sustainable management with a quality first management philosophy, is to see every day as a chance to be successful in a way that makes a difference.

As such, the sustainable management of the Dongdaemun merchants will be to ship newer, more diverse, and high-quality fashion products to the splendid show windows like at apM Place.

The marketing strategy pursued under the banner of "There is nothing but novelty," is, as it has been, a new, expanded road to the future of Dongdaemun market.

Sell them Confidence

"I have always believed that fashion was not only to make women more beautiful, but also to reassure them."[22]

As such, Yves Saint Laurent said that consumers should be given confidence along with fashion products. And Blake Lively also said that the most beautiful anyone can wear is confidence.

As we knew well, any Koreans prefer folk wine instead of beer or imported wine at restaurants. A plum wine called 'Soon', products of Bohae Brewery Company, which maintained market strength along with Jinro, was once very popular. The company sometimes experienced supply shortages when demand for hit products increased explosively.

Someday, the company held an emergency executive meeting to find a way to solve the supply shortage. The

problem was that the very hit products that had aged for five years was no longer in stock.

At the meeting, an employee suggested replacing the hit products with a three-year-old to solve an urgent supply shortage. The very suggestion of one employee was that in order to prevent the company's public credibility from falling due to a supply shortage, it would be necessary to label 3-year-aged products as 5-year-aged products.

Then, the company's founder, and CEO Yim Gwang-haeng, spoke quietly, persuading employees to stop supplying the products for the next two years.

"When our company brews alcohol, we must always love our customers like family and friends, and communicate with them. In other words, the spirit of brewing should always be directed towards people."[23]

His words like this are acceptable as a English proverb, "You must drink as you have brewed." Anyway, Bohae is continuing its sustainable management thanks to the entrepreneurship of the founder, which is described as 'Give them confidence', although a decrease in sales was inevitable in the short term.

Dongdaemun merchants must also ensure that domestic and foreign buyers have faith in their fashion

products. That is the right path to sustainable commerce management. Although the fashion products they purchase are inexpensive, they should have the perception that the quality and consumer satisfaction of the products are consistently good.

Fashion consumers probably want to satisfy emotional satisfaction including the style or lines, fabric, and color of the products rather than the number of clothing tags.

Some global SPA brand companies are trying to sell more of their fast fashion products by making them cheaper and cheaper. Dongdaemun merchants, however, should give fast fashion in one hand and confidence in the other.

That is the Dongdaemun-style of commerce that gave birth to the myth and wrote the epic. Dongdaemun fashion products are surprisingly equipped with various competitive advantages that can satisfy the needs of consumers.

Unfortunately, the trust in Dongdaemun products from many domestic and foreign fashion retailers and overseas buyers is not very high. In fact, the excellence of many fashion products in the market has improved, but the reality is not well known.

Despite its speed, products, and price advantage, its

reliability is quite low. That's why we are right when a fashion legend says, "Confidence is everything."[24]

In other words, instead of anyone selling fashion products, the people of Dongdaemun market should sell confidence of the products.

Of course, quality control in Dongdaemun market is not easy because it is checked through the hands of many people, including wholesalers, designers, fashion parts suppliers, workers in sewing factories, and workers in the logistics and service sector.

Rather, prior to quality control, it is right to say that building and maintaining confidence between partners on the supply side is an urgent priority. That is also why the partnership between them is emphasized.

In any case, it will gradually get better if we always pursue the 'common good', such as talking, checking, helping each other, checking for errors, and improving. Everyone has to sell them confidence together.

As such, sustainable management should give priority to supplying good quality products. This is because the value of quality is the confidence that satisfies customers.

"It is better safe than sorry."[25]

This is an iron rule that Dongdaemun market people should not forget beyond providing more customer service.

<Notes>

1 David Pearson, The 20Ps of Marketing, Kindle eBooks

2 Alber Elbaz was an Israeli fashion designer. He was the creative director of Lanvin in Paris from 2001 until 2015

3 google.com/search/q?

4 Erin Huffstetler, "How to Spot Quality Clothing," liveabout.com

5 www.kfashinnews.com.

6 dongdaemun-style.blogspot.com

7 Joonang Ilbo, October 11, 2017.

8 Al Ries and Laura Ries, The Fall of Advertising and the rising PR, Harper Business, 2002, pp.239-268.

9 Ibid.

10 Prime English-Korean Dictionary, 6th Ed., www.bookdonga.com, 2021.

11 Theodore Levitt, The Marketing Imagination, New York, Free Press, 1983, 2019.

12 Suh Kyung-bae, Chairman of Amorpacific, Interview, Chosun Ilbo, December 18, 2014.

13 www.walmart.com

14 Prime English-Korean Dictionary, 6th Ed., www.bookdona.com, 2021.

15 Ibid.

16 The fashion revolution that is taking place under this slogan is currently in progress., globalfashionrevolution.org/about

17 Wilbur Suen, April 9. 2016, aroimak.com

18 The Survey, The Cotton Inc., Life-style Monitor.

19 Ibid.

20 The Balance website

21 google.com/search/q?

22 Ibid.

23 www.bohae.co.kr

24 "You must drink as you have brewed."

25 Prime English-Korean Dictionary, 6th Ed., www.bookdona.com, 2021.

Part
9

The Moment of Truth

Give and Take

Jeju, the largest island in Korea is known as a place where many foreigners want to go sightseeing. It is also a place that is widely praised for its fantastic scenery as if the gods stayed there.

Anyone who goes there will be able to see traces of a female merchant Kim Man-deok doing moral commerce in the late 1700s.

Jeju Island is now a blessed land visited by many tourists, and its residents are also wealthy. Even 200 years ago, however, poor farmers and fishermen lived there in quite difficult.

According to records, in 1795, after a long drought, many residents of Jeju island starved and the number of deaths increased day by day. In the old days people said,

"Poverty cannot be saved by even a king."[1]

Especially in Jeju, an island far from Seoul, it would have been more difficult to rescue all of them even if many residents were dying due to drought.

At that time, the merchant princess Kim Man-deok disposed of all the money and property she had earned throughout her life, purchased large quantities of grain from the land, and donated it to the people of Jeju island.[2]

The following year, the reformist King Jeongjo, who pursued modernization at the time, praised her moral commerce and social action of virtue and invited her king's palace in Seoul, as well as gave her the benefit of a tour of the world's most beautiful Mt. Geumgang.

The commercial behavior of merchants in Dongdaemun market has in inherited the tradition of the moral commerce of Mrs. Kim, who made a lot of money based on the credit with the trading partners and gave back to society the money and fortunes earned in her lifetime.

This is worth discussing. Dongdaemun market wholesalers have partnerships with designers, fabric and parts suppliers, and employees of sewing factories, and they help each other and manage them together.

In addition, the people of Dongdaemun market who are trying to do customer satisfaction management, con-

tinue to do business at night for the convenience of domestic and foreign fashion retailers and buyers.

In fact, Dongdaemun market has a bad image because of some merchants who frequently engage in immoral transactions such as fake brand products. Despite these criticisms, most people in Dongdaemun market are well aware of the importance of moral commerce. And they recognize the necessity of sustainable management through fair trade and corporate social responsibility.

Founded in 1938 and Korea's No. 1 scale and excellence, Samsung, its founder, Chairman Lee Byung-cheol, had a unique entrepreneurship. He said that a corporate deficit is a social sin, and it is the mission of entrepreneurs to create profit and surplus through rationalization of management and contribute to the country and society.[3]

Like Samsung's management philosophy, all of sustainable companies must make a lot of money through management rationalization and strong market competitiveness. It is a businessman's dream and the true value of business life. Koreans said,

"Loving one's neighbor comes from a full warehouse of the rich."[4]

This proverb is also not wrong. We want the mer-

chants in Dongdaemun market to make a lot of money amid stable sales growth. Also, we hope that they will always be happy with a warm heart to love their neighbors like our merchant princess.

We know well that Mrs. Kim Man-deok was a lifesaver to all Jeju people today. She gave back the money she earned during her life to society and inherited the virtue of such moral commerce to us. As if she is still living with us now, she will always be hoping that the people in Dongdaemun market will continue their stable business and live better with neighbors.

Of course, dreams and reality are different. In fact, the people of Dongdaemun market are facing a crisis of survival because of the long-term recession.

Be the matter what it may, however, they seem to be supported by hope for the future. In a new horizon targeting the global market, they will be able to overcome these big crises with innovative marketing strategies such as online and un-tact commerce.

The Moment of Truth

Customer service strategy is the top priority in fashion biz and its marketing. It is the 'moment of truth' itself that customers often feel when the executives and employees of a company give them a bonus for sale or provide shopping convenience.

A better customer service strategy not only increases customer awareness of the brand of a company's products, but also creates interest, love, and even their loyalty to the brand. Someone is saying this.

"Loyalty is something money cannot buy."[5]

Of course, many customers are not impressed with the bonus or convenience of purchase alone. Even without such customer service, the satisfaction they get when they sell better quality products at lower prices creates loyalty to the brand. Everything comes from a moment of truth.

Needless to say, such a better customer service of any company often improves the company's management performance while increasing the level of loyalty of the customers to a brand. That is why Nordstrom, a prestigious department store, is captivating the hearts of many shoppers with this customer service strategy. This is the code of conduct that department store executives have.

"Be willing to say 'Yes!' every time."[6]

Mr. Lee Yong-woo, CEO of an export company of Dongdaemun fashion sent a message as follows.[7]

"In the catastrophe of Covid-19 pandemic, we will seek online and un-tact trade for buyers and retailers around the world through rationalization of the supply-side management. The rationalization of such a management not only balancing the importance of products, speed and price, but also controlling of quality with a strong inspection system."

"In particularly, we are continued the management of our inspection system as a customer service strategy. Because, if we take care of our customers, they will remain our customers for a long time. We hate that a miss is as good as a mile."

We believe that he is managing to continue the moment of truth that loves customers. Under this manage-

ment philosophy, he always asks the executives and employees of his company to join him.

Recently, we also have been talking about 'Employee satisfaction first, then customer service.' US American Air aims for this customer service strategy in the same sense.

"Treat your employees as your first customers."[8]

Prior to USAA, Southwest Airlines in the United States has pursued an innovative management strategy that prioritizes employee satisfaction over customer service.[9]

Of course, such a management strategy, at first glance, is accompanied by a reduction in the customer service budget due to the limited management resources of the company, but the sincerity of the employees may rather increase customer satisfaction.

In fact, Southwest Air executives said that the quality of their customer service is highly regarded thanks to the bright smiles of the employees along with discount tickets.

Nowadays, many companies are benchmarking Southwest Air's customer service strategy, and such a strategy will allow any company to expect high performance. Once again, let's take look at the management philosophy of

SeoulClick.[10]

"Up to the present, while improving the quality of work life in our company, we are shouting 'Let's work together' for true customer satisfaction management. Thankfully, our company's employees are working at the risk of their life, agreeing with this management philosophy."

CEO Lee Yong-woo's management mind is also excellent, and his thinking as follows can be seen as a Dongdaemun-style of fashion biz.[11]

"As a company's representative, I am happy to do difficult and hard work with my employees. We know well that working at our company is a condition of happiness, like family, love, and money. I am just proud of the employees who voluntarily love the company and work."

"We will pursue the sustainable management of our company so that all of our executives and employees, and buyers or retailers from all over the world, as well as our supply-side partners, are happy."

Such a customer satisfaction management strategy is difficult to implement, but SeoulClick's actions are worth paying attention to. As we discussed customer loyalty to a products brand, loyalty to the customer is also very

important.

U.S. president George Washington's speech, "Without loyalty, you would not accomplish anything." is also interpreted as saying that it is difficult for any fashion company to improve its management performance if it is low in loyalty to its customers.[12]

Generally speaking, consumers are strong than a merchant in any market. Such was the case. However, despite such facts as 'the Iron Law', there are many merchants who neglect customer service.

This customer service strategy should be considered important regardless of domestic and foreign markets. As the marketplace expands into the global market, however, we will have to continue the moment of truth toward customers more and more.

Ecology and Fashion Marketing

"The Korean New Deal is the architect to design the Republic of Korea's new century."[13]

Under this banner, Korean government has selected 10 signature projects for the 'Digital New Deal' and 'Green New Deal,' two pillars of the Korean New Deal roadmap, including eco-friendly mobility, a smart healthcare infrastructure, green energy, and the digitization of social infrastructure.

The Korean New Deal was a long-term plan with an amazing national budget. In particular, like the chorus of people from all over the world, "Let's save the one our Earth!", the Green New Deal will be an opportunity to advance the sustainable growth of the Korean economy.

In the endless fashion revolution of the world, the Korean Green New Deal should also stimulate and sup-

port the sustainable growth of K-fashion business. The manifesto for the world's fashion revolution is widely sympathetic. "We love fashion. But we don't want our clothes to exploit people or destroy our planet. We demand radical, revolutionary change. This is our dream..."[14]

Merchants in Dongdaemun market are loved by global consumers as they produce and supply good fashion products more quickly and at lower prices. Especially for them, sustainable fashion marketing is possible by selling designer products with newness and diversity at low prices.

In the mood of the global fashion revolution, however, Dongdaemun market people need innovative marketing strategies to produce and sell eco-friendly fashion products too. Much of all, they should prioritize improving the economic and emotional value of Dongdaemun fashion products through the use of natural fibers such as cotton or silk and rest of it.

Of course, natural fibers such as cotton and silk have been regarded as high-cost raw materials and parts due to the comparative advantage of production during the development and growth of the Korean economy.

Nowadays, however, the development of smart farms armed with AI, robots and drones has made it possible

to improve the productivity of such a natural fiber and increase its comparative advantage. It's an amazing good news.

"Our Nuetown (Buan Silkworm Complex) is contributing greatly to the development of the fashion and bio industries, including the production of colorful cocoons and cosmetic ingredients to promote health, as well as mass production of silk thread."[15]

As we all know, after industrialization-driven economic growth, rural areas in Korea have undergone changes such as population reduction, labor shortages, and farmland idleness amid the change of production structures. There, the 4th industrial revolution is taking place, led by smart farms, with the production of rice no longer increasing and the labor-intensive production system collapsing.

The Korean Green New Deal, which is being planned in time, will be an opportunity to grow into a global production base for eco-friendly textile industries such as cotton and silk in rural areas. This sustainable policy approach compares to the fashion industry environment in many foreign countries where large quantities of chemical fibers are supplied instead of natural fibers such as cotton and silk.

In the future, the Korean Green New Deal will contribute to opening a new way for Dongdaemun people to supply eco-friendly fashion products at lower prices thanks to mass production of natural fibers in the rural area. Such a strategic alternative should be refined by benchmarking the sustainable business case of Shinsegae group, a famous department store in Korea.

The company's fashion brand Jaju, which has a partnership with Cotton made in Africa, an international labeling organization that supports many African farmers, is conducting sustainable management such as eco-friendly fabrics, subsidiary materials and fabric recycling.[16]

Meanwhile, Luis Casacuberta, managing director women's & kids' part at Mango said.

"Corona is no excuse to back off from sustainability. Moreover, sustainability will be key factor of excellent products, together with quality and durability."[17]

We must listen to such a warning. Now is the time in which we have to make an innovative decision. And, at this very moment, the words of Warren Buffett come to mind.

"Never put your all eggs in one basket."[18]

This is a piece of advice which means that one should not concentrate all efforts and resources in one

area. It also means that they have to become newer in the rapidly changing market conditions inside and outside.

They need a movement of collective intelligence to open a new path for sustainable fashion management in a hurry. New challenges and responses from the people of Dongdaemun market are required anew.

Finishing Strong is Epic

As mentioned earlier, Koreans often say the proverb that well begun is half done. Likewise, many people agree with the phrase that a good beginning makes a good ending. And also, the sooner we set about it the sooner we'll finish.

On the other hand, according to Canadian writer Robin Sharma, it is more important not how to start, but how to finish. This is exactly what he said.

"Starting strong is good, finishing strong is epic."[19]

The CEO and staffs of SeoulClick, an export agency of Dongdaemun fashion products, believe that quality control is important and are doing their best in the inspection procedure, which is the final stage of commerce. We are well aware that SeoulClick's quality management is an excellent commercial strategy.

In any company, such quality management is key to

achieving the business performance of the firm. The case of 'New Management', which has taken a long journey toward qualitative growth instead of quantitative growth, is a good example of this.

As we widely knew, the Samsung Enterprise Group, which had been grown by founder Lee Byung-chul, from before the development era to the end of the 1980s, has maintained its status as the number one company in Korea. Until then, however, the company did not reach the market position of a global company as it is today.

After that, Chairman Lee Kun-hee, who took over the management of the company, realized that the company has achieved quantitative growth, but qualitative growth is slow. In particular, he sighed and even became angry at the market status where Samsung Electronics Company, one of the main firms was far behind the technological level of competitors such as LG, as well as other companies in Japan and the United States.

When he went to Los Angeles, U.S.A. for an emergency meeting with Samsung executives, he saw Sony products on the show window at the electronics store there, but found that Samsung products were left in a warehouse for inventory. At that time, he probably had

a big shock.

The shock that he received in 1993, the fifth year of Lee Kun-hee's chairmanship was the starting point for Samsung's innovative management, also known as Samsung's New Management.

In an urgent meeting with the executives that followed after that, he suggested that Samsung should pursue qualitative growth rather than quantitative growth in the future, and change everything except wife, son, and daughter. The following is a statement from Chairman Lee Kun-hee.

"We, Samsung, have to make the world's No. 1 products. ...Of course, the task is difficult. But I will dedicate my life, wealth, and honor to this goal. Even if I don't bear the fruit and I die, the honor that ends life, leaving a chapter of history for our juniors and descendants, will surely remain forever."[20]

In 2004, ten years later, when I was in the U.S. as a visiting scholar, I saw that Samsung's electronic products was placed instead of Sony brand on an electronics store's show window there. It was amazing. Rather, it was an epic of Samsung's 'New Management' strategy pursued for 10 years. As we all know, Samsung Electronics Company has now become the number one

company in the world, and its products are loved by people around the world.

Dongdaemun merchants are getting better management performance by manufacturing and selling fashion products at lower prices. In order to continue this Dongdaemun-style of fashion biz, however, it will be necessary to listen to the words of a legend. As quoted earlier, this Gucci slogan comes from the founder's own quote. "Quality is remembered long after price is forgotten."[21]

They, Dongdaemun merchants will have to recall and remember this quote at the last minute in the unique commercial process of manufacturing and selling Dongdaemun fashion products. This seems to be the reason why SeoulClick puts a large amount of human and physical resources in order to inspect well in the final process of commerce for Dongdaemun fashion products.

As quoted earlier, Samsung's legendary chairman Lee Byung-cheol said that company are not a charity. At the same time, he argued that a company's deficit is only social criminal. His management philosophy was that all companies should aim to increase corporate profits, expand the size of firms, pay more taxes to the state, and increase the quantity of employment. He had a true en-

trepreneurship that has fulfilled its social responsibilities.

Under this repeated discussion, we want to praise the marketing strategies of Dongdaemun wholesalers expanding the global market through quality management, even though the distribution margin is very small. We are always talking.

"Lightly won, lightly held."[22]

Dongdaemun wholesalers are well aware that quality is first and last the only requirement, but it is not easy for them to manufacture at lowest cost and buy and sell at low prices according to such inevitable demands of global market. Fortunately, the experience of handling difficult tasks is a great asset to them.

Whatever it is, it has to be well done to the end. Because, there is a slip between the cup and the lip as Westerners says.

Mind over Matter

Won Hyo was a monk who lived in the Unified Silla dynasty and he is a historical person who had a reputation not only in the Buddhist world, but from lots of foreigners.

"The world of life is all in the mind and the phenomenon is only recognition. Everyone depends on their minds. But people always try to get something out of their minds."[23]

According to this logic, Won Hyo discussed that conflict also come from 'discriminatory mind'. We are happy because we can boast a historic person such as Buddhist leader Won Hyo. The legendary happening that Won Hyo experienced is famous.[24]

As a youth, he had to sleep overnight somewhere on the long way to study abroad in Tang dynasty, the ancient land of China. Then, on a dark night, he slept in

a cave under the hill. After waking up thirsty, he groped in the dark and drank some water from the jar.

When he woke up the next morning, he was amazing that he slept in a crypt where an old tomb had collapsed. And he was even more surprised that the water he drank last night was in a human skull. At that very moment, he was suddenly nauseated and seemed to vomit.

At that moment, he realized that the water he taken itself wasn't dirty or clean, it just depends on his mind. Then he gave up studying abroad and returned to the land of Silla, eventually becoming a world-class Buddhist scholar.

In this way, the source of Won Hyo thought seems to have its roots in the mind. The mind he recognized was interpreted as a mirror that embraces everything, just as the vast ocean receives all flowing water, whether it is clean or dirty water.

Even before the Covid-19 pandemic, some Dongdaemun merchants had a negative outlook for the future along with the difficulties of the market. Nevertheless, they have endured difficult situations with a thin hope that the future of the market will improve.

As each person has different perceptions and pre-

dictions of the present and future market conditions, the management performance of merchants will be greatly affected by their mindset as implied by the Won Hyo ideology.

The industrial hero who led the development of Korean economy and its miracles Hyundai motor and its corporate group chairman Chung Ju-young are widely known to people around the world.

As his younger brother, Chairman Chung In-young founded and led the Halla group. However, the company faced a big crisis due to the political repression of the government, which came to power in a coup d'état in the 1980s, and eventually closed. After that, he started a new auto parts company, Mando, with the idea of "Man do!" and continued his business again. The resolution to understand his entrepreneurship is as follows.

"When I lost everything, I could no longer be caught up in anger. Wouldn't adversity be a solid asset for another new start? I promise to shake off adversity and start anew."[25]

Whenever he was weakened in his mind, he said alone, as above. He woke up at 2:00 in the morning and went to several domestic factories and took the business trips overseas to the United States and Japan

almost every three days. So, after running busy for 10 years, one day, he was hospitalized with a stroke. Despite the concerns of many, however, he soon recovered and returned to his office in a wheelchair.

Sitting in a wheelchair, he moved earlier, farther and faster than before. The company continued to grow rapidly, and finally rebuilt a larger heavy industry company on the stolen factory site.

This management case of overcoming this crisis is understandable as an empirical test of the logic of mind over matter.

"Mind over matter represents the triumph of will over physical hindrance. Our thoughts are our weapon against the world."[26]

As such a meaning of mind over matter, Chairman Chung In-young overcame many difficulties with a strong mindset and achieved surprisingly better management performance. As one U.S. President Theodore Roosevelt said, "All resources we need are in the mind." Chairman Chung also proved.[27]

Dongdaemun merchants are well aware that life is more of a famine than an abundance. The economic fluctuations and business cycles of the Dongdaemun market were also more in recession than booms.

Moreover, their traders, whose management scale is small and their market competitiveness is weak, often rely on mind, that is, invisible resources, rather than visible resources such as capital size or number of employees, for the survival of the company every year. What can be faithful is a strong mindset.

Why aren't people saying faith will move a mountain! Some of the latest books said that the mind takes precedence over matter in the digital age, and the introduction of AI to improve productivity also requires the mind and its innovation. That's why, in any organization, the mindset of its members and people-centered management are very important.

Like the meaning of 'mind over matter,' we are well aware that someone is able to control a physical condition, problem, etc., by using the mind.[28] Based on that, the people of Dongdaemun market have their own unique fashion business strategy.

<Notes>

1 That's a Korean proverb.

2 ko.wikipedia.org/wiki/

3 www.samsung.com.

4 That's a Korean proverb too.

5 dongdaemun-style.blog.spot.com

6 en.wikiperdia.org/wiki/Nordstrom.

7 www.seoulclick.com.

8 en.wikipedia.org/wiki/American air

9 American Air homepage

10 www.seoulclick.com.

11 Ibid.

12 www.google.com/search/q?

13 www.gov.kr

14 Why we still need a fashion revolution, white paper, 2020.

15 www.buan.co.krnuetown/

16 Newsis, Feb. 7, 2022.

17 www.google.com/search/q?

18 Ibid.

19 Ibid.

20 Samsung and Lee Kun-hee, kpior.kr 2012, pp.249-250.

21 www.google.com/q?

22 Prime English-Korean Dictionary, www.bookdonga.com, 2021.

23 Bong (Bong-sik) Sul, Dongdaemun Style, ebook.kstudy.com., Seoul, 2019, pp.44-45.

24 www.naver.com.

25 The Korea Economy Daily, Chung In-young, 2007, pp.25-27.

26 www.google.com/mind-over-matter-

27 google.com/search/q?

28 The phrase "mind over matter" first appeared in 1863 in The Geological Evidence of the Antiquity of Man by Sir Charles Lyell, www.google.com

246

What a Wonderful Marketplace

Phoenix Management

Just as there are steep hills and deep valleys whenever we climb a certain mountain, it is true that the road to growth and maturity of Dongdaemun market was accompanied by light and shadow.

Needless to say, it is difficult for anyone to go through a deep valley to a steep hill and their footsteps also are slow. This was in the early 1970s, when the second decade of development had just begun. At that very time, someone made this desperate appeal on the street.

"Comply with the Labor Standards Act. We are not machines. We should rest on Sunday. Don't overwork the workers."[1]

On the afternoon of November 13, 1970, Jeon Tae-il, a sewing worker at the Pyeonghwa market, fell on the spot while shouting a few slogans. He set himself on

fire by spraying gasoline on his body, leaving only ashes to us.

Nowadays, 50 years later, in many developing countries, global SPA brand companies that manufacture and sell under the conditions of worker exploitation and environmental degradation are also being criticized by the world people without exception. This is a very serious situation.

Such a situation also happened half a century ago, and at that time, Jeon Tae-il chose the path of great sacrifice by committing suicide.

One female politician said that her lovely ten-year-old daughter had read a book about a young man, Jeon Tae-il and cried while saying this question. "Why does he burn himself, hot and sore?" And, the child trembled and suffered, and was afraid of why people had to burn his body.

As the child's mother, she also recalled the memories of tears pouring down after reading "The Story of Jeon Tae-il" written by lawyer Jo Young-rae for the first time a long time ago.[2]

The people of Dongdaemun market have not forgotten Jeon Tae-il's shouting, "Don't let my death be in vain!" As the history of the Pyeonghwa market reconstructed

from the ashes, they are overcoming so many business crises thanks to their commerce innovation and its strategies. Like a phoenix, it has continued a business life of sustainable commerce.

According to Egyptian mythology, the phoenix is a bird that lives for more than 500 years, burns itself and is reborn from the ashes, so it is a bird that lives forever like magic. The myth is unique in that it comes to life from the ashes. Janet Fitch said.

"The phoenix must burn to emerge."[3]

It means that a phoenix cannot be revived unless it burns itself to ashes. Likewise, Dongdaemun market has expanded since the 1990s, but the market environment deteriorated and the business crisis did not stop.

Then they had to make a shocking innovative decision. In particular, the great crisis in which continued on the demand side overlap with the difficulties on the supply side.

Art Plaza, a wholesale shopping mall newly opened on those market crisis, has set up new marketing and promotion strategies, such as attracting chartered buses, for the convenience of fashion retailers and buyers, and extended the opening of their stores from the morning to midnight of the previous day.

Of course, soon after that, most wholesalers in Dongdaemun market changed their business hours from around 8:30 the night before until dawn, giving many fashion retailers the convenience of doing their business during the day. Dongdaemun market, both in name and reality, was open all night and after closing its doors at dawn, it was soon named 'Tokkebi market'.

The Tokkebi market was born from the 'phoenix ashes', like the great fire at Pyeonghwa marketplace and Jeon Tae-il, who burned himself.

Dongdaemun market has expanded in commerce size due to the innovative management of such wholesale malls that satisfy buyers. Thanks to this, Dongdaemun market achieved the booming Dongdaemun myth despite the 1997 IMF foreign exchange & financial crisis and contributed to overcoming the low-growth Korean economic crisis.

As such, the Dongdaemun market has been continuously growing in search of new opportunities for innovation amid commercial crises. And in this way, Dongdaemun market wrote a history of repeated hardships and prosperity.

Then, the Dongdaemun market is facing another great crisis after the Covid-19 pandemic as we are all having

a hard time, such as a contraction in production of fashion products, an inadequacy in supply-side partnerships, and an endless decrease in consumer demand.

In this crisis, Dongdaemun market people are looking for new innovative strategic tools such as online and un-tact commerce, smart manufacturing and its management. This is a new phase that again requires tough innovation decisions and determined courage.

As discussed previously, during the Imjin war, which began with the Japanese invasion in 1592 and lasted for seven years, Admiral Yi Sun-sin once said to his soldiers on the battlefield: This is widely known.

"Those who seek death shall live. Those who seek life shall die."[4]

Now, Dongdaemun merchants are walking the path of a innovate commerce, like the joy of a hero who was "reborn from the ashes."

With the mysteriousness of phoenix, we praised the mindset and behavior of the people of Dongdaemun market, and even attached a sub title called 'Phoenix Management'.

Merchant Prince's Dignity

In the late 1700s, Park Ji-won, a scholar of the Silhak school wrote the novel 'The Story of Heo Saeng'. As a servant of King Jeongjo of the Joseon dynasty, he, like other Silhak scholars, criticized the old feudalistic notion that ignored the prosperity of commerce and its importance.[5]

Unfortunately, many feudal scholars, Seonbis have held the view that commerce in which some goods are bought cheaply and sold at high prices is an immoral act of making money easily without working.

At that time, however, scholars of the Silhak school thought that commerce was productive like agriculture and manufacturing, and it compensates for the excess and shortage of production and consumption areas through exchange, and further increases national wealth with the surplus.

Since Heo Saeng, the protagonist of the novel, was a poor scholar, he went to see Mr. Bae, a rich man in Seoul, to borrow seed money from his business to make money in commerce. He was surprisingly able to borrow 10,000 Nyang in old currency from the rich man. On the first meeting, the rich man did not know who the Seonbi dressed in shabby clothes is. However, he lent money to Heo Saeng, without a guarantee or an IOU.[6] Warren Buffett said,

"The rich invest in 'time', the poor invest in money."[7]

Come to think of it, Heo Saeng met a rich man with a truly commercial mind investing in time and people rather than money, and think to that, he set out on the path of a dreamlike business. Thus, he made a lot of profits by buying and selling fruits in a region close to Seoul, and then, with increased capital, he continued to do business with new items in Jeju, the largest island in Korea.

Heo Saeng made a lot of commercial profits by purchasing horse hair, which was the raw material for the traditional hats of the Yangban, the ruling class of the Joseon Dynasty, from Jeju island, a grazing region of horses, and selling them on land. In the meantime, he learned a thing or two in commerce well.

After that, he obtained a huge trade surplus by selling grain to famine-stricken Japanese land and eventually became a merchant prince.

At a glance, he achieved great commercial prosperity as a poor Seonbi, but his dream was in something else. He gathered the unemployed and needy, like today's homeless people, and moved together to an uninhabited island in the South Sea, Korea. Later, people assumed that the uninhabited island was once Okinawa, a Japanese island where our ancestors lived and ruled.

Heo Saeng, who went there together, removed the old feudal customs, their inefficiency, and their illness, and built a new welfare society, perhaps a world like the utopia, under the ideology of nationalism and modernization. It's such a story long to tell.

In this classic novel, we learned that a merchant prince can achieve a great management performance when he does not simply make money, but invests time and people, manages more rationally, and goes on to give virtue throughout. It was the dignity of a merchant prince.

As a matter of fact, it is no different from the proposition of sustainable management we are discussing today. The Dongdaemun market people, descendants of Heo

Saeng, are trying to improve the quality of work life in the market by selling newly and various fashion products to global consumers at as low price as possible.

In a situation where there is nothing to laugh, we were listening to the desperate speech of Mrs. Jeong Eun-kyeong, chief of the Korea Centers for Disease Control and Prevention.

"For solidarity, we must be scattered."[8]

This paradoxical statement emphasizes that in the Covid-19 pandemic, there was no other way than social distancing for the health of all citizens. And, such a speech of Mrs. Jeong, who devoted herself to elevating the national status as a model country for K-quarantine by successfully overcoming the crisis of Covid-19 pandemic, was quite persuasive.

In an empty market where sellers and buyers cannot met, the spread of online and un-tact commerce could become another new horizon for achieving happiness together, even if they are scattered.

Needless to say, online and un-tact commerce requires quality management strategies such as better design and style of fashion products, input and use of high-quality raw and subsidiary materials, sewing and technological advances and productivity improvement.

We are now discussing the moral commerce of a merchant prince, Heo Saeng, the protagonist of the classic novel, and his dreams. Any fashion biz company must conduct sustainable management that can satisfy both producers and consumers through ethical commerce. It is an indispensable condition for not only the survival of a company, but also to achieve great management performance and become a merchant prince.

In particular, the online and un-tact commerce that Dongdaemun merchants are aiming for now must be reasonable and good management. In other words, it should be recognized that the etiquette of commerce is important, and that etiquette is important not only in the real world but also in cyberspace.

The etiquette of online and un-tact commerce, namely, netiquette is as a compound word of network and etiquette should put people first. It is clear that such commerce without netiquette is really difficult to acquire customers, and furthermore, it will be difficult to achieve sustainable management of the company.

New Normal of Fashion Biz

Blake Morgan predicted the trends going into the future of fashion marketing in December 2020, when the coronavirus pandemic causes stagnation of global economy.[9]

First, in the future, data-driven fashion business and marketing strategies will become commonplace. Therefore, many fashion business companies will obtain quickly detailed market information to understand consumer preferences and demand in the midst of rapid changes in trends, and will make more rational decisions that much.

Second, sustainable fashion biz is not a matter of choice, but will become an inevitable new normal. Fashion products that fit the trend, the brand will be manufactured with eco-friendly fabric and parts. In addition, along with the improvement of sewing technology, people-centered innovation toward a smart factory will

also be possible.

Third, in the future, digitalization will become common in the fashion industry and its scope of use will expand. In other words, many fashion companies will be able to generalize online and un-tact commerce. In addition, it is clear that digitalization will follow in various tasks such as new products development, design, and sewing.

Fourth, fashion biz and its service strategy will be more simplified. This means that the accumulation of experiences gained in the catastrophe of Covid-19 pandemic will improve productivity in commerce and delivery services for fashion products with the help of AI or robots.

Just like this, the new normal of fashion biz, the future situation of Dongdaemun market will also change greatly. Predictably, domestic and foreign fashion retailers, buyers, and tourists who visit Dongdaemun market someday will be surprised to see monorails operating, drones flying around, and busy robots moving in the marketplace.

"Is it really the same market as Dongdaemun market before?"

In the meantime, Dongdaemun market has been oper-

ating a labor-intensive logistics system and its operation. In the future, however, the speed of the logistics service will be greatly accelerated by artificial intelligence, the IoT, and autonomous vehicles.

As such, Dongdaemun market, which is moving toward the future, will be able to maximize the management performance of low-cost commerce through innovation in logistics services based on automation and robots.

Fortunately, LogisAll, a partner of SeoulClick, made a business proposal to speed up the innovation of logistics services that can overcome the difficulties of high cost and low efficiency currently facing Dongdaemun market. That's a good word too.

In the marketplace, there will be a syndrome where amazing management performance of fashion biz such as the Amazon effect is expected.

Amazon CEO Jeff Bezos knew very well that "global consumers everywhere want better fashion products at lower prices and faster delivery."[10]

Needless to say, the company's business performance, called the Amazon effect, was driven, among other things, by innovations in the logistics system based on online commerce. It is worth benchmarking broadly.

On the way to this future, the people of Dongdaemun market are still busy. Although market situation and its conditions are difficult during the economic crisis, Tokkebi market, which is open only at night, is still busy. Of course, vain dreams do not bear fruit because they do not have seeds. On the other hand, if anyone works hard like sowing seeds, the dream becomes a reality. When a dream becomes reality, it will probably become science.

Dreams are science. That's right.

Creative Destruction

In the meantime, wholesalers in Dongdaemun market have grown with a unique marketing strategy of 'selling good fashion products at a cheap price'. But recently, local retailers and foreign buyers visiting Dongdaemun wholesale market has declined its size significantly.

As a result, many people have been greatly worried about such a difficult situation of Dongdaemun market. Is Dongdaemun market a chronic management crisis? Or is the market's future situation really dark?

Instead of answering this question, we need to think about the causes of today's management crisis in Dongdaemun market.

Depending on the idea, the fundamental factors are the deterioration of the fashion business environment amid difficulties in the late stage of growth and development, as well as challenges and weakening competitive-

ness in the global market. As well as, there is a big reason for the rapid increase in the size of online commerce.

On the other hand, such an increase in online commerce in the Dongdaemun market has paradoxically provided new opportunity to overcome management crisis of the market.

Today, many fashion retailers and global buyers do not come anymore to Dongdaemun market to buy fashion products. But they still buy Dongdaemun fashion products. Rather, the purchase volume of them is increasing. They have developed a strong preference for globally-minded ecosystems and platforms, such as Amazon, Alibaba, Facebook and Google, and so on.

Likewise, merchants in Dongdaemun market are dramatically increasing the size of online commerce according to their demands and trading patterns, such as retailers, buyers, and even consumers.

"Best place to find your style! Meet on mobile, check various and luxury fashion items right now! Take new arrival every week."[11]

Dongdaemun wholesalers, who have strong market competitiveness, are doing innovative marketing to increase the scale of online commerce. In addition, in Dongdaemun market, many wholesalers are using 'online

commerce' as their top priority marketing strategy.

Furthemore, while the global spread of the coronavirus that originated in Wuhan, central China, is expected to continue, 'un-tact marketing & shopping' that avoid face-to-face contact between the seller and buyer is increasing more rapidly in Dongdaemun market.

In this growing trend of online commerce, we can argue that Dongdaemun market is rewriting the 1st Dongdaemun myth that happened over 20 years ago. Rather, it is true that the curtain of the 2nd Dongdaemun myth has already risen.

Not widely known, SeoulClick has not only purchased by proxy, but also inspects purchased products, improves product value by repairing defective products, and provides services like packaging and delivery.

The company has increased the number of employees responsible for 'online trading' and to expand work of inspecting & improving facilities, and so on. Here we need to recall L'Oreal CEO Ago's argument for the future of E-commerce.

"E-commerce isn't the cherry on the cake, it's the new cake"[12]

That's right. As one Data analyst at Neuro, Neelesh Vasnani views, we need to understand these trends and

ideas and pursue new fashion business strategies. The question will be whether we are ready with that mindset.

There is no end to the management of creative destruction by Dongdaemun market merchants. In a new world, an infinite virtual world realized digitally, they will conduct fantastic commerce that transcends time and space.

Metaverse is a compound word of meta, which means processing and transcendence, and universe, which means the real world. That fantastic place is a new, larger space revealed by new technologies such as VR and hologram.[13]

Since the advent of digital games, it has been connected to the virtual world, and as a result, the unprecedented metaverse has expanded beyond games into a tool for daily business and communication.

In Dongdaemun market, many wholesalers are increasing their commerce volume through 'separately and together' collaborations and partnerships in such a virtual marketplace.

They seem to be using such a new fashion biz as a new opportunity to overcome the market crisis. It's amazing.

Dongdaemun Fashion Revolution

Recently, SeoulClick received a certificate from the Korean government that it was selected as a 'Global Leading Company 1,000 +'. It is good news to receive such an honorable award as a small but strong fashion trading agency in Dongdaemun market.[14]

In the midst of the Dongdaemun market crisis, such a big news about a company's marketing performance will receive wide attention.

As we knew, Dongdaemun market wholesalers have sold a lot of designer fashion products of better quality at lower prices. Generally, however, it is not easy to sell high-quality designer fashion products at low prices. It is also true that it is difficult to continue wholesale commerce with fast-paced fashion design and its production according to rapidly changing trends.

Despite these difficulties, Dongdaemun wholesalers are

making great management performance through triple management which focuses on superiority of products(good), speed(fast) and price(cheap).

Thanks to this triple management strategy, Dongdaemun market has received attention from people around the world. Around the year 2000, numerous domestic and foreign fashion retailers and buyers came to Dongdaemun market. So, it was famous enough to be praised the so-called 'Dongdaemun myth' over the market boom at that time.

After that, Dongdaemun market expanded greatly into a huge shopping mall for fashion products like today. Surprisingly, however, today, 20 years later, Dongdaemun market is facing an unprecedented management crisis.

The crisis in Dongdaemun market is facing a serious syndrome on both the demand side and the supply side. Judging from the demand-side crisis, the long aftermath of Covid-19, which turned the world upside down as well as the long recession of the world economy, was very large.

In addition, in the midst of a great transition from the analog and offline era to the digital and online era, the Dongdaemun market is in a more serious crisis as it fails to establish and operate a system suitable for the

new era.

It's late, but now is a golden opportunity. Dongdaemun wholesalers must overcome the catastrophe-like market crisis while adapting to the new paradigm of the digital and online era.

The problem is that Dongdaemun wholesalers are still not properly establishing and operating a reasonable business model for better management performance. A strategic solution is urgently needed.

The seriousness of the problem is emerging on the supply side too. Until now, Dongdaemun market wholesalers sold designer fashion products at low prices and had strong market competitiveness, but a big problem still remained.

In other words, from the standpoint of Dongdaemun wholesalers, better designs and high-quality fashion products should be sold at lower prices, but the sewing factories and their executives and employees are unable to lower their shipping prices any longer because of high production costs.

As such, the crisis in Dongdaemun market is due to the slow management innovation, such as improvement of the production system and cost management of sewing factories scattered in Gangbuk, Seoul.

As discussed earlier, the management innovation of sewing factories and its structural change is also many like (1) progress in specialization, (2) division of labor and productivity improvement, (3) expanding outsourcing scope, (4) mass production of personalized fashion products, and (5) broader cooperation and alliances, and so on. The question is how to solve it.

In this urgent situation, Lee Yong-woo, CEO of SeoulClick, signed a business agreement with Park In-cheol, CEO of Sewing Line Technology, and they began to cooperate in creating a smart system for Dongdaemun sewing factory and the environment for its operation.[15]

The new system management of the sewing factory is based on IT technology such as IoT data's control and sharing to achieve better business performance.

Here, IoT data is operational information of a manufacturing plant, such as manpower, facilities, average working hours, fixed expenses, and operating expenses. In addition, IoT data is used as smart information by extracting production cost data for products to be produced by creating work standards for currently ordered projects.

In this way, the LTM sewing smart system will provide a total of 7 functions essential for production and

management for sewing factories 'together and separately' through partnership. The seven functions are as follows.

(1) Systematic record of orders and its orders

(2) Remote delivery of work instructions to the work site through the LTM system terminal

(3) Real-time productivity monitoring by workplace, process, worker, and products

(4) Identification and control of bottlenecks in the production process

(5) Performance management of all field workers

(6) Registration and management of production facilities, and formation of accurate process lines suitable for new orders and products

(7) Maintaining the balance of the production process

From now on, small but strong sewing factories in Gangbuk, Seoul will be able to achieve great management performance by operating the factory based on division of labor, specialization, and outsourcing. Just now we dare to say this.

"All is now in train."[16]

Certainly, the people of Dongdaemun market are fully prepared to establish a new strategy for the sustainable management of the fashion biz and to provide better customer service to fashion retailers and buyers at home

and abroad.

The marketplace there is not only the site of sustainable fashion biz, but is also the land of biz life where both supply-side and demand-side partners are happy.

\<Notes\>

1 Jo Jung-rae, Jeon Tae-il (Revised ed.), Beautiful Jeon Tae-il, Yes24, 2021. Ibid.

2 Ibid.

3 Janet Fitch's a quote, Johnnie L. Roberts, The Big Book of Business Quotations, Skyhorse, 2016, p.251.

4 a dialogue in Myeongrang, a Korean film

5 In the late Joseon Dynasty, the modernization idea that commerce made the country rich and strong prevailed.

6 www.naver.com/the-story-of-heo-saeng

7 www.google.com/search/q?

8 www.gov.kr

9 www.forbes.com/sites/blakemorgan/2020/03/the-fashion-industry-is-

10 logistics.amazon.com/

11 apM Place's management strategy

12 https://www.linkedin.com/pulse/future-e-commerce-2030-

13 www.businessoffashion.com/article/s/technology/can-the-metaverse-transform-fashion-business-models/

14 www.gov.kr

15 www.seoulclick.com

16 Prime English-Korean Dictionary, www.bookdonga.com, 2021.

"Let us work for a better future."

Even nowadays, whenever anyone goes to Dongdaemun market, they will hear this phrase, which was a buzzword in the era of development. Doubt it, but it's true.

Like Thomas A. Edison's iconic quote, they seem to believe there is no substitute for hard work. Surprisingly, they say this word in the late stages of development.

In fact, people in Dongdaemun market have a lot of worries under the chronic management crisis. Of course, overcoming of such a crisis is not easy. But they just work hard, taking the crisis as an opportunity.

It all depends on one's mindset. We have seriously discussed 'mind over matter' in this book. This discussion is closely related to the economic term 'Entrepreneurship.'

Dongdaemun market people's fashion business and marketing have also achieved performance based on the

mindset of "We can live well, too" rather than capital, technology, other resources, or market size, and so forth.

In this sense, this book analyzes the fashion biz in Dongdaemun market, which is based on the entrepreneurship of merchants, and further theorizes the biz model.

I would like to say that this book was published with the guidance, encouragement and help of many people.

Firstly, I would like to thank the merchants at Dongdaemun market and everyone else who works in the marketplace. In particular, Lee Yong-woo, CEO of SeoulClick, where I am involved an advisor, gave me a lot of material support and a golden opportunity to write several books. I am grateful to him.

In the early 2000s, I toured Dongdaemun market, which is open at night with our college students. After 10 years, in the mid-2010s, I came back to Dongdaemun market and had the opportunity to empirically research the market. From then on, as an advisor in SeoulClick, I visited the market once or twice a week to meet and talk with people and organize what I saw and felt.

Thanks to these and other field experiences, I was able to write three books after that, titled Dongdaemun Market and Its Dream (Korean version, 2018) and Dongdaemun

Style (English version, 2019). Dongdaemun-style of Fashion Marketing (Korean version, 2021).

I thought that if any fact is given and persisted, theorization is possible. With this mindset, I wrote those books.

Secondly, I would like to say thank to Kim Yun-sun, the founder and CEO of Beomhan Bookstore, who left us a few years ago. This is an interview with a newspaper reporter of Kim Yun-sun, CEO of Beomhan Bookstore, which was founded in 1956.

"Even if there are many difficulties in managing a foreign bookstore, I thought that books were the only way to accept the science and culture of advanced foreign countries. Seeing the business as a heaven-given job, I felt even more rewarding as I provided educational and research materials to university professors and students while doing business."[1]

There is good reason why I felt grateful to Chairman Kim Yun-sun. When I was young, as a lecturer at one university, I went to the bookstore there often. Since my salary was not much, there were many times when I bought new books on credit. I paid a bill as part of my salary, but the amount of credit purchases accumulated quite a lot. The total amount of credit was rough-

ly 70% of the price at that time of a small house in the suburbs of Seoul.

After some time, the angelic CEO Kim Yun-sun forgave a poor scholar like me for the cost of the large amount of credit. I owe him a lot indeed. But I couldn't thank him directly too.

Thirdly, I would like to thank the following two people for laying the theoretical foundation for this book to be well written.

Among them, Professor Baek Young-hoon, who was a teacher at the university, would like to thank once again for teaching me Joseph Schumpeter's economic theory that entrepreneurship is a very important factor in the economic development of a country.

As another senior, I would like to thank Chairman Kim Jong-bok, who has been a life-long expert as Korea's first fashion education institution since the 1960s, for reminding me that fashion business can also be explained as a marketing theoretical tool.

Lastly, I would like to express my gratitude to Chae Jong-jun of Korea Academic Information Co., Ltd. and all of its employees for taking charge of the publication of this book despite the slump in the publishing industry as it is today.

"There is only one happiness in this life to love, and be loved."

Like a quote of George Sand, I receive a lot of love, and I am happy to be able to express my gratitude and love even if it is late.

In this final stage, I hope that the people in Dongdaemun market will be happy. Of course, things are tough. May be tough it out.

The solution is not far to seek. This is a word to emphasize again.

Now, I hope many readers have enjoyed reading this book. How about saying this? "I would like all of you to be my friends."

And I would like to thank them.

<Notes>

1 MK News, October 10, 1970

278

Fashion retailing, where and how to purchase

-dongdaemun-style.blogspot.com

How to make money? <1>

"Happiness is not in money, but in shopping." An actress Marine Monroe said. Consumers are generally satisfied with purchasing fashion products of designer brands at low prices. Yes. Happiness is in such a smart shopping.

In this situation, many fashion retailers are making a lot of money thanks to supply-side partnership in Dongdaemun market.

Let us go on a tour to the marketplace there.

The birthplace of K-fashion <2>

In downtown Seoul, there is Dongdaemun, a classical castle with a history of 600 years, and ultra-modern buildings DDP. Around those two landmarks, there is Dongdaemun market.

Dongdaemun market is a large-scale marketplace that has been manufacturing and selling fashion products.

The market is even more famous for being the cradle of K-fashion, which is loved by people around the world today.

Path to profit maximization <3>

"Fashion products are good, fast, cheap, and pick two options from them."

In other words, most of fashion products cannot satisfy all three of the requirements.

Surprisingly, however, Dongdaemun wholesalers are the only suppliers in the world who have requirements such as products, speed, and price.

Dongdaemun market allows fashion retailers to maximize their profits.

Dealing with wholesalers as a producer <4>

The etymology of marketing is understood as 'market' plus 'ing.' Therefore, it can be said that marketing is a job in the marketplace.

Dongdaemun market has been founded and grown with the business framework of 'manufacturing and selling fashion clothes 'in the marketplace.

We can say that Dongdaemun wholesalers are not a selling, but maufacturing. The starting point of their marketing strategy depends on what and how it is produced.

High priced products, no sales & profits <5>

Luxury fashion products are new and of good quality, but the prices are surprisingly high.

To many ordinary citizens, looking at expensive fashion products in a shopping mall, they simply see them as cakes in the painting. For that reason, the market size is small.

On the other hand, Dongdaemun wholesalers continue to trade with good products, fast speed, and low prices. In particularly, the Dongdaemun wholesaler, which sells designer brands at low prices, is a fantastic supply part-

ner!

Make them a supply-side partner like a blood brother. Because, blood will tell.

Fast fashion without diversity, the crisis <6>

Global SPA brand products are cheap, but the quality is not very good, and the novelty and variety are insufficient. Uniqlo's founder Tadashi Yanai also stated. "Uniqlo is not a fashion company, it's a technology company."

On the other hand, Dongdaemun wholesalers continue to trade with good products, fast speed, and low prices.

In particularly, Dongdaemun wholesalers are merchandising by manufacturing fashion products of various items that fit the trend every three days.

Do you know the 3-day miracle? <7>

"This market is a miracle site where design, production, distribution and consumption take place in just 3 days."

Pyeonghwa market in Dongdaemun shopping district, which has been manufactured and sold in one store since the late 1950s, is advocating such a slogan. The

three-day miracle of Dongdaemun market is a valuable reward for accumulating experience gained through hard work under 'the quickly and quickly spirit' unique to Koreans.

Very few have seen such a market anywhere else.

Smart sewing factory and productivity <8>

Today's global consumers generally purchase fashion products according to the following purchasing priorities. The priorities are (1) design, (2) quality, (3) brand, and (4) price.

In this way, although price has a low priority in preference, the price level sometimes even changes the purchasing behavior.

Therefore, many sewing factories in Gangbuk, Seoul is also looking for ways to supply at low prices.

Now, many Dongdaemun sewing factories are trying to increase productivity.

What a big fashion wholesale market <9>

Dongdaemun market is being led by wholesalers. There are 30,000 small but mighty wholesale stores in about 30 wholesale trading malls. No other country has

such a large-scale wholesale market.

The wholesale market there is an attractive source of fashion products for many fashion retailers and buyers around the world thanks to the novelty and variety of merchandising.

Everything will be fine there.

K-fashion market as an advanced country <10>

As the declaration announced by UNCTAD in May 2021, Korea became the first country in the world to go from an underdeveloped country to an advanced country.

Dongdaemun fashion and its style are also the pride of Koreans who have become a citizen of developed country.

More interestingly, Dongdaemun market sells better quality designer products at lower prices.

Easily launch your own brand shop <11>

Now, job opportunities are decreasing and the era of start-up has come instead. Someone said.

"I have a dream. It is to manage my own boutique. And I want to fill the shop with MDs of my own

brand."

It is only urgent to establish a PB brand strategy and find a good supply-side partner.

There is an easy strategic alternative.

Find products like pearls in the mud <12>

Fashion products in Dongdaemun market are generally cheap. That is why the image of a fake fashion market sometimes follows.

Just as there are many pearls in the mud, however, there are quite a few high-quality products shipped in the wholesale markets.

So far, many Dongdaemun fashion products were exported in the form of PB products.

Inspection guarantees quality <13>

Since Dongdaemun market is like a huge jungle, it is very difficult for overseas buyers to purchase good products at low prices in the marketplace.

Therefore, they are inevitably guided and help by someone. To get such a service, anyone will need to contact a supply-side partner who acts as an export agent on a turnkey basis.

SeoulClick provides purchasing agency services for fashion products to many buyers. Others are included too,

(1) inspects of purchased products, (2) repairing defective products, (3) labeling, (4) packaging, and (5) delivery, etc.

Influencer and fashion marketing <14>

Influencer is now a popular career choice for young people. In the fashion business, influencers' start-up is particularly booming.

In this way, influencer's fashion marketing makes a lot of money by gaining trading margin without expensive advertising.

The problem is that in fashion biz, the management performance of influencers depends on how they do merchandise.

Therefore, they should prioritize partnerships with buying agents in large wholesale malls.

Start-up and gateway to success <15>

With fewer and fewer job opportunities, the era of start-ups has come. As we already discussed, that is

right.

In the fashion business founded by many influencers, there are many strategic challenges in marketing. For example, it is,

(1) products development, (2) market research, (3) advertising, (4) PR, (5) sales, etc.

If you work with a purchasing agency like seoulclick. com, you will easily get better marketing performance.

The Tokkebi market is indeed fantastic <16>

Because Dongdaemun market is open for wholesale trading at night, people call it the Tokkebi(Goblin) market.

For the convenience of retailers and buyers, the Tokkebi market open from 8:30 p.m. to early morning the next day.

In that market, many fashion businessmen at home and abroad are earning a lot of money through wholesale trade, just like the magic of a Tokkebi's bat.

"First catch your hare, then cook him."

Value of products in perfect competition <17>

"The battle is not always to the strong."

In pure competition like Dongdaemun market, many small and medium-sized wholesalers and their suppliers are gaining trade performance through designer brand for less.

In the market, there is no transaction unless it is an item of designer products with a low price.

The roots of Korean CSR <18>

New Il-han, founder of Yuhan Corporation, one of the 100-year-old companies, left a valuable message for us.

"Production of high-quality, low price is the ABC of corporate achievement. But it is also a CSR(corporate social responsibility)."

Like many Korean businessmen, the conscious Dongdaemun merchants do not forget the widely respected Ph D. New Il-han's quote.

Customer-first and Tokkebi market <19>

Wholesalers in Dongdaemun market have started trading 'at night' to save time and purchase convenience for domestic fashion distributors and overseas buyers.

That is the customer-based fashion biz strategy of

Dongdaemun wholesalers.

Obviously, the customer is king.

Design is the beginning of fashion <20>

About 100,000 designers are valuable assets of Dongdaemun market. Even though the wages and earnings are low, they are not avoiding hard work.

Not only that, they know the proverb that "fine feather is fine bird," and they keep working on better designs.

Dongdaemun fashion's market competitiveness is strong in that there are many designers with such passion.

Surprisingly, among Dongdaemun designers, there are many technicians with craftsmanship.

Designer as an entrepreneur <21>

Coco Chanel was the most influential fashion designer and one of the most successful business women in history.

Dongdaemun designers have entrepreneurship as a merchant like her.

Now, they want to do smart work with the experience and know-how accumulated through hard work.

There are many fashion products of novel design.

Inspiration from Seoul Fashion Week <22>

Seoul Fashion Week, which is held twice every year since 2000 has become widely known as world's top five collection on ddp(Dongdaemun Design Plaza).

Thank to such a global fashion shows, Dongdaemun market is shipping products with good designs that fit the trend.

In addition, it helps to quickly adapt to trend changes, improve quality of products, and establish better marketing strategies.

Productivity of smart sewing factories <23>

Many employees of sewing factories around Dongdaemun market have worked hard to succeed.

In the meantime, the employees of Dongdaemun sewing factory have accumulated experience and know-how while doing hard work.

Thanks to this, they continue to improve productivity based on smart work. This is also the reason why Dongdaemun fashion can sell better quality designer products at a cheaper price.

The sewing factories are small but strong.

The law of scissors & profit maximization <24>

Do you know what is the law of scissors? Scissors larger than any other can cut paper or fabric well. Likewise, the better the quality of some products, and the lower the price, the better it sells.

From this point of view, the law of scissors is that the larger the gap between the quality of any fashion products and its price, the larger the sales scale of that products.

According to this law of scissors, many domestic and foreign buyers are achieving profit maximization.

Craftsmanship of Designers <25>

Do you know how famous luxury ceramics from the Goryeo dynasty in the early 10th century were?

Today, Dongdaemun designers are designing with the craftsmanship of the ancestors who made Goryeo Cheongja by themselves.

Anyone can buy the fashion products there. Thomas C. Gale said.

"Design adds value faster than it adds costs."

Confidence & entrepreneurial designers <26>

Quite a few designers are an important human resource in Dongdaemun market.

The role of a fashion designer is different for each company, but as an entrepreneur, a fashion designer should have a customer satisfaction management mind along with creative design.

There are so many entrepreneurial designers in Dongdaemun market. It is the pride of the market.

Market with fabric and parts for designers <27>

"When anyone went to the market, they will be deeply impressed to see that many fabrics, their parts, accessories, and other things are trading a lot."

A British fashion apparel importer said. He also said that anyone will be pleased to be able to purchase the desired fabric and its parts at a reasonable price in the mall.

Now, SeoulClick is achieving global marketing performance by selecting, inspecting, and exporting fabric and parts as well as finished products.

Fortune favors the brave.

Hanbok is also a fashion item <28>

The painting 'Portrait of a Beauty,' the work of the famous painter Shin Yun-bok (1758-1813) of the Joseon dynasty, is an immortal cultural asset and is probably popular anywhere in the world.

This painting depicting the beauty of a woman in that time is a masterpiece comparable to the Mona Lisa.

In addition, the fashion design of the hanbok worn by the woman in the picture also made us admire.

Dongdaemun merchants manufacture and sell beautiful hanbok and its fabric to fashion retailers and buyers around the world.

Get some business inspiration from there!

Consumers are getting smarter <29>

"Instead of focusing on the competition, focus on the consumer." A director of eBay Scott Cook said.

We agree his opinion like above. Above all, consumers will have their desire to shop for designer brands at lower prices.

Because many fashion retailers and buyers are aware of consumer needs and wants, people in Dongdaemun market are selling them designer products at low prices to

help them.

Dongdaemun wholesalers are small but strong in a perfect competitive market.

Hard work and a desire for success <30>

Even in the syndrome of the post industrialization era, Dongdaemun wholesalers are working hard for the convenience of fashion retailers and buyers.

An Indian singer Sudhashree Acharya said,

"The harder you work for something, the greater you will feel when you achieve it."

As such a quote suggests, Dongdaemun wholesalers are making remarkable marketing performance.

In the circle of safety <31>

The godfather of the automakers, Henry Ford said.

"Coming together is a beginning, staying together is progress, and working together is success."

As in this discussion, Dongdaemun market is achieving great management performance by having partnerships with wholesalers, designers, sewing factory employees, and others.

They have strong market competitiveness thanks to

the circle of safety through partnerships.

No cent no sense <32>

"Wise merchants go 'Sipri(4km)' to go to 'Ori(2km).'"

Like such a Korean proverb, even if there is a loss in the short term, they will achieve great management performance in long run.

'Give and take', giving first and getting later is a rational trading.

There is no accounting for tastes <33>

This is not the era of mass production of fashion products. That is because each consumer has different tastes.

SeoulClick will be of great help in selecting and purchasing novel and diverse fashion products for buyers from more than 30,000 wholesale shops.

Having such a good partnership with them.

Online trade with a purchasing agency <34>

Online and un-tact commerce has become commonplace in any fashion wholesale market. In this situation,

fashion retailers and buyers should prioritize partnerships with purchasing agency.

In particular, knock on a purchasing agency such as SeoulClick that has an inspection system.

No matter what, finishing well is beautiful.

Experience, knowledge, and trial & error <35>

"The customer invents nothing. New products and new services come from the producer." W. Edwards Deming said.

Dongdaemun fashion suppliers such as designers and sewing technicians are developing new products well from experience, imagination, and trial and error.

It is a fruit obtained from a long history of the market.

Find products for customers <36>

"Do not find customers for your products. Find products for your customers." Milton S. Hershey said.

A lot of customers come to us when we find a good products and have an optimal MD.

In Dongdaemun market, more than 30,000 wholesalers are waiting for buyers from all over the world with

MDs such as newness, diversity (breadth) and assortment (depth).

Maybe now is the era of merchandising rather than marketing.

Hanllyu(Korean wave) and K-fashion <37>

As you know well, the Korean wave (Hallyu) refers to the global popularity of South Korea's cultural commodity exporting K-pop, K-entertainment, K-drama & movies.

Meanwhile, the Hallyu stars as well as apprentices, and many unknown stars who aspire to success often are wearing reasonably priced designer products from Dongdaemun market.

Dongdaemun market continues to grow thanks to a kind of star marketing with many Hallyu stars.

Price or products, that is the question <38>

Recently, many fashion consumers are changing their consumption behavior based on the quality of the products rather than the price.

Nevertheless, many fashion consumers still buy designer products at low prices.

Under these circumstances, fashion retailers need to have better supply-side partnerships while adapting to changes in consumer behavior.

What a large-scale supply infra <39>

Dongdaemun market is stronger than ever with the smooth supply of new and diverse fabric and parts under a tight supply chain system.

"When I visited the fabric market, I realized that there was a great deal of small and medium-sized stores. Such a marketplace is not found in any other European country."

This is the discussion of Aaon Dezonie, a CEO of a British clothing import company.

Finishing is important for good quality <40>

"Starting strong is good, finishing strong is epic." Robin Sharma said.

In fact, the establishment of SeoulClick's inspection system enables continuous quality management of products.

The steps and process are (1) size measurement, (2) detailed inspection, (3) labeling, (4) ironing, (5) wrapping in plastic bag, (6) bar-code attachment, (7) packing

box and deliver service.

Let us tour the big fabric market <41>

"The fabric is like drawing paper, which is indispensable for the realization of a design. By analogy with farming, design is like choosing a crop and growing it well. In this way, the fabric can be described as a field that enables a good harvest." See the Ellin blog.

SeoulClick, an export agency, is achieving global marketing performance by selecting, inspecting, and exporting fabric and parts as well as finished products.

Start-up and risk aversion <42>

"You only get a short life, so take chances." John Galliano said.

In Dongdaemun market, there are many opportunities for start-up one of the fashion retailing with supply-side partnership.

Particularly, any fashion retailing with the purchasing agency can be successful thanks to cost-saving and risk aversion.

Jeon Tae-il and fashion revolution <43>

Do you know who Jeon Tae-il was?

In front of the Pyeonghwa market, he himself ended his life at the young age while protesting for the improvement of the quality of work life. It was in the early 1970's.

Obviously, he was not a simple labor activist, but rather a fashion revolutionary.

Maximize the retailer's trading margin <44>

We knew that "A phoenix cannot be revived unless it burns itself to ashes."

Now, Dongdaemun merchants are walking the path of innovation in commerce, like the phoenix, who must once again "burn one's body to ashes" just as the hero Jeon Tae-il cried.

Partnership with purchasing agency <45>

Dongdaemun wholesalers have the advantage of selling quality designer products at cheaper prices. For that reason, it is possible to maximize the transaction margin of retailers who purchase and sell Dongdaemun fashion products.

The problem is that retailers lacking market information can make the wrong purchases and fail to maximize margins.

The strategic alternative is to have a good partnership with a purchasing agency in the market.

The dexterity of Korea sewing technicians <46>

Dongdaemun fashion products are of good quality thanks to the dexterity of the skilled workers of numerous sewing factories.

The dexterity of Koreans is widely known to people around the world during the development and growth of the Korean economy.

Sewing technicians who inherited the skills of brass chopsticks unique to Koreans are also making and selling high-quality fashion products.

Every day is fashion show <47>

"Fashion is not something that exists in dresses only. Fashion is in the sky, in the street. Fashion has to do with ideas, the way we live, what is happening." Coco Chanel said.

With 100,000 designers, Dongdaemun wholesalers are

trading new products of creative destruction to the market every three days.

It is no different from holding a fashion show every day.

What a strong power of products <48>

In the perfect competitive Dongdaemun market, however, they are continuing with self-sacrificing low-cost management to sell designer products at low prices.

It is an inevitable marketing strategy for corporate survival. That is why they are small but strong.

Fashion retailing and 'Just in time' <49>

In the past, Toyota Motor has reduced costs by manufacturing as much as the quantity demanded every day.

It was a JIT strategy, a management technique to zero inventory burden.

Similarly, many fashion retailers can manage their inventory without burden by purchasing in Dongdaemun market.

This is because Dongdaemun market is a supply-side partner capable of new and diverse merchandising.

An inspection process <50>

Dongdaemun market has strong competitiveness in that it manufactures high-quality designer products according to trends and sells them at low prices.

Therefore, we have been proud of Dongdaemun market as a marketplace that manages three factors like products (good), speed (fast), and price (cheap).

To be honest, two issues such as speed and price are OK, but quality is still an issue. The solution is there.

It is also OK when going through an inspection process as in SeoulClick.

A large number of items-small quantity production <51>

Dongdaemun style of fashion biz is achieving the great management performance under a large number of items-small quantity production system,

It is different from other markets where oversupply occurs under the small number of items-mass production system. This is also the cause of the long-term stagnation of the fashion business.

In fact, Dongdaemun wholesalers are small, but their market competitiveness is strong.

Fashion and 3p marketing mix <52>

As we all know, the marketing mix is based on the strategic elements of the 4Ps like products, price, place, and promotion.

However, Dongdaemun market accepts 3P marketing strategies such as the first products, the second products, and the third products.

In particular, such a strategy is inevitable in the midst of market crises that come cyclically.

In other words. quality is, first and last, the only requrement.

Dongdaemun merchants' dreams are science <53>

Vain dreams are explained as unfruitful because the seeds were not sown.

On the other hand, if anyone works hard like sowing seeds, the dream becomes a reality.

Dongdaemun wholesalers have made their dreams come true by working hard day and night.

What a wonderful marketplace <54>

There is a marketplace where wholesale commerce takes place day and night. In Dongdaemun market, many fashion retailers and buyers are conducting commerce well, while overcoming the barriers of time and space.

Don't forget the marketplace, where anyone can get generous customer service.

FASHION BIZ
IN
DONGDAEMUN
MARKET
SEOUL

초판인쇄 2023년 11월 30일
초판발행 2023년 11월 30일

지은이 설봉식
펴낸이 채종준
펴낸곳 한국학술정보㈜
주 소 경기도 파주시 회동길 230(문발동)
전 화 031) 908-3181(대표)
팩 스 031) 908-3189
홈페이지 http://ebook.kstudy.com
E-mail 출판사업부 publish@kstudy.com
등 록 제일산-115호(2000. 6. 19)

ISBN 979-11-6983-826-9 13600